GRETA GERWIG

ICONS OF CINEMA

First published in the UK in 2025 by Studio Press,
an imprint of Bonnier Books UK,
5th Floor, HYLO, 105 Bunhill Row,
London, EC1Y 8LZ

Copyright © Laura Venning, 2025

1 3 5 7 9 10 8 6 4 2

All rights reserved.
ISBN 978-1-80078-984-5

Written by Laura Venning
Edited by Stephanie Milton
Designed by Maddox Philpot
Production by Holly Porter

This book is unofficial and unauthorised and is not endorsed by or affiliated with Greta Gerwig.

A CIP catalogue record for this book is available from the British Library

Printed and bound in China

The authorised representative in the EEA is Bonnier Books UK (Ireland) Limited.
Registered office address: Floor 3, Block 3, Miesian Plaza
50–58 Baggot Street Lower,
Dublin 2, D02 Y754, Ireland.
compliance@bonnierbooks.ie

www.bonnierbooks.co.uk

The publisher would like to thank the following for supplying photos for this book: Alamy, Getty and Shutterstock. Every effort has been made to obtain permission to reproduce copyright material but there may be cases where we have not been able to trace a copyright holder. The publisher will be happy to correct any omission in future printings.

LAURA VENNING

GRETA GERWIG
ICONS OF CINEMA

UNOFFICIAL AND UNAUTHORISED

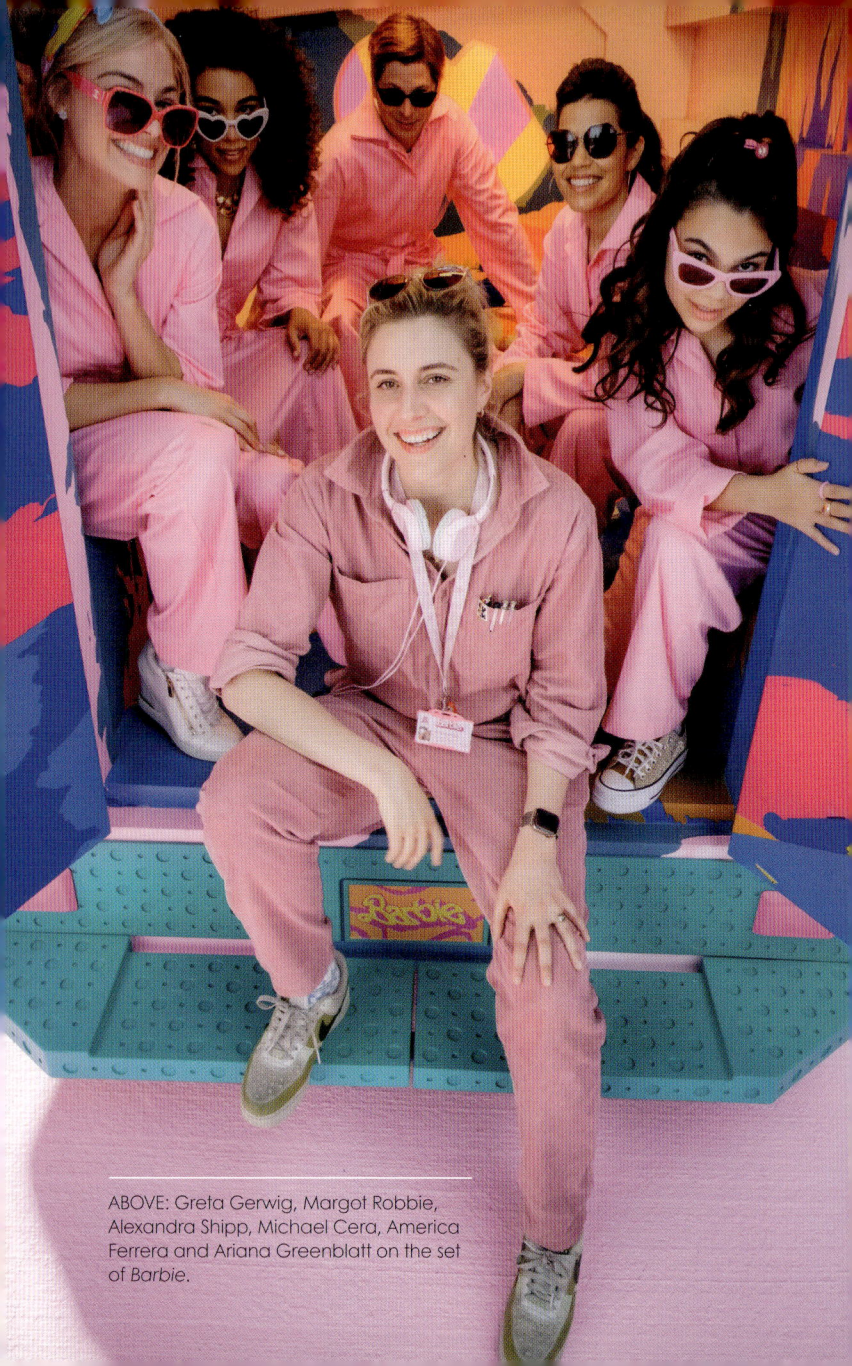

ABOVE: Greta Gerwig, Margot Robbie, Alexandra Shipp, Michael Cera, America Ferrera and Ariana Greenblatt on the set of *Barbie*.

Contents

Welcome to the Gretaverse 7
A New American Auteur 8
Sacramento 10
Gotta Dance! 12
"I wanna go where culture is!" 14
Mumblecore 16
Indie Stardom 19
Hollywood 21
Greta and Noah 23
Greta and Greenberg 24
Frances Ha 27
Finding Frances 28
A Different Kind of Love Story 30
One Defining Scene:
The Secret World 34
Mistress America 36
Brooke Cardinas:
America's Heroine 40
Brooke and Tracy 42
One Defining Scene: A
Whirlwind Night with Brooke 44
Behind the Camera 48
Greta Gerwig the Writer 48
Fragments of
Inspiration 50
Greta Gerwig the Director 51
Inspirations and Encouragement 54
Lady Bird 57
Conception 60
Casting 62
Greta and Saoirse 68
Greta and Timothée 70
Cinematography 72
"Is it too pink?":
Costume and Set 74
Greta on Set 80
Score and Music 82
One Defining Scene: "Did you
feel emotional the first time
you drove in Sacramento?" 84
Time to Fly: 89
Little Women 90
A New Generation 92
The Adaptation Process 94
Drawing Inspiration from
Louisa May Alcott 98
Louisa, Greta and Jo 101
Creating the March Family 102
The Reimagining of
Amy March 106
Creating the World of Little
Women: Cinematography 110
Creating the World of Little
Women: Production Design 112
Designing the March Sisters:
Costume and Hair 114
Jo 116
Amy 118
Meg and Beth 118
One Defining Scene:
Reclaiming Jo March 120
"I want to be great or
nothing" 124
A Return to Acting 126
Barbie 128
Greta and Barbie 130
Writing Barbie 132
Who is Barbie? 134
This Barbie is Having an
Existential Crisis 136
I Am Kenough 138
Creating Barbieland 140
"Did you bring your
rollerblades?": Costume 142
Kenergy through Costume 146
One Defining Scene:
I'm Just Ken 148
The Dream Ballet 150
Living in a Barbie World 152
**Through the Wardrobe:
Greta Gerwig's The
Chronicles of Narnia** 154
Coming of Age in the
World of Greta Gerwig 156

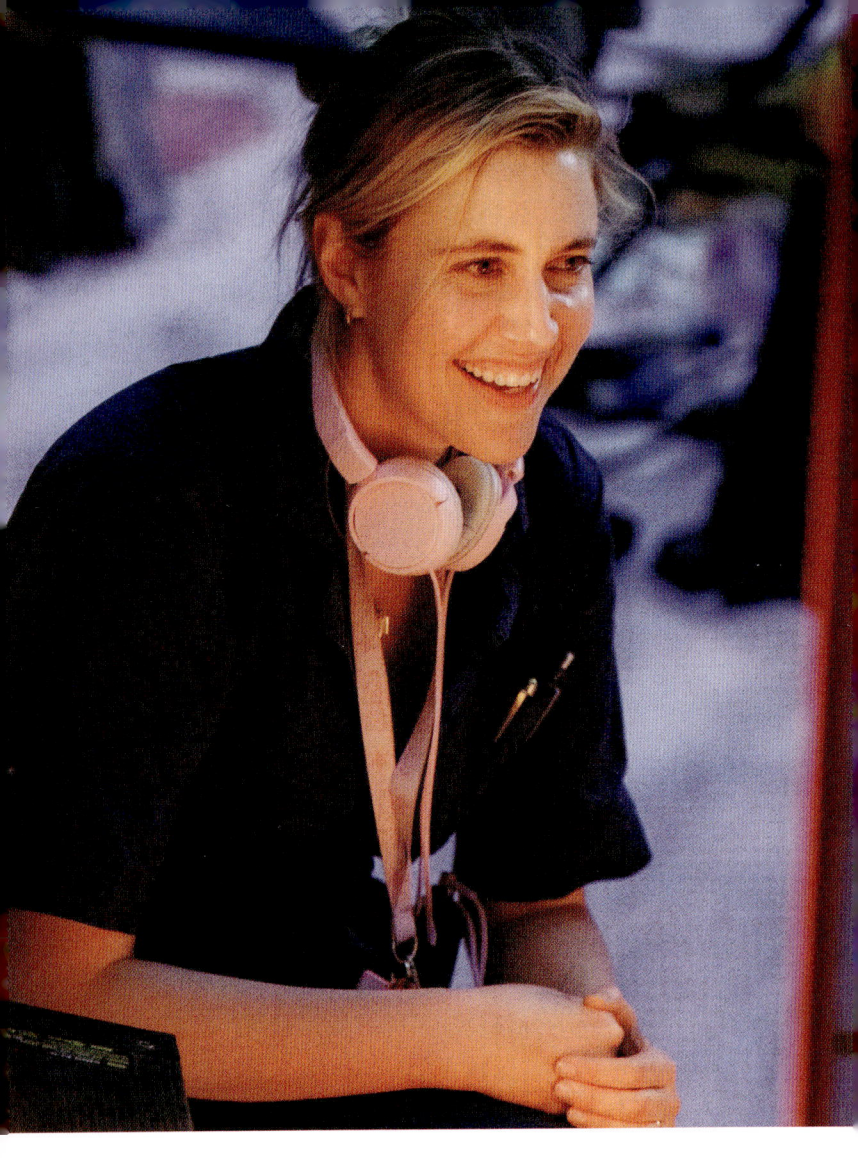

ABOVE: Gerwig directing *Barbie*.

OPPOSITE: Gerwig attending the Cannes Film Festival 2024.

Welcome to the Gretaverse

There aren't many directors who are genuinely household names – perhaps only Hitchcock, Scorsese, Tarantino and Nolan would make the cut. But in just a few years Greta Gerwig has achieved what most filmmakers won't accomplish in a lifetime.

Adored by audiences and critics alike, Gerwig is one of only a handful of Hollywood filmmakers who has conquered the box office without sacrificing her own unique, deeply personal creative voice. She's also probably the only female director to have made such a gigantic, pink-hued leap, and she just might be the future of movies.

A multi-hyphenate from the early days of her career, Gerwig has made her mark as a writer, actor, and director ever since she gained cult it-girl status as part of the 'Mumblecore' film scene of the mid 00s. Her performances in these semi-improvised, ultra-low budget films made her the epitome of offbeat cool. She eventually began to play lead roles in higher budget indie films like those written and directed by her husband, Noah Baumbach, with whom she has two sons, as well as supporting characters in more mainstream films.

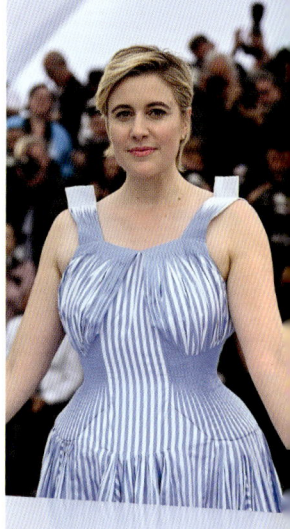

A New American Auteur

Once she stepped behind the camera to write and direct *Lady Bird* (2017), she announced herself as an extraordinary new filmmaking talent and a chronicler of the last years of girlhood. Audiences fell head over heels in love with Saoirse Ronan's sharp-tongued, painfully real heroine. From then on, Gerwig's films would become touchstones for young women searching for themselves and for their experiences to be taken seriously. "I know what it is to want things," says young heroine Tracy (Lola Kirke) in *Mistress America* (2015), one of the films she co-wrote with Baumbach – a sentiment that's a through line in all her work.

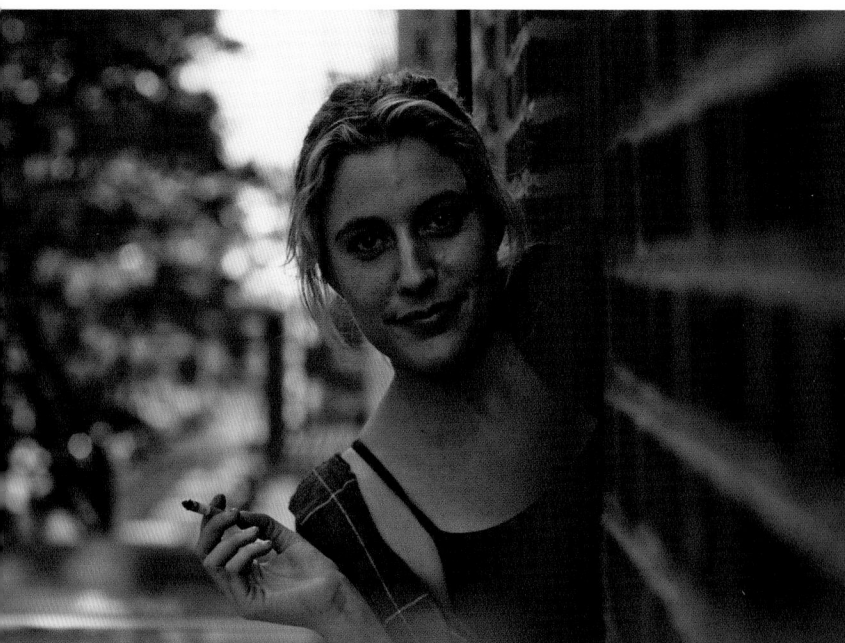

From *Lady Bird* to *Little Women* (2019) to *Barbie* (2023) and now *The Chronicles of Narnia*, Gerwig has embraced her ambitions and crafted women's stories of longing and self-realisation on even bigger canvases. From a childhood spellbound by Technicolor Hollywood musicals like *Singin' in the Rain* (1952) to orchestrating 'I'm Just Ken' in *Barbie*, Gerwig has brought her creative dreams to life – dreams that are still grounded in totally real emotion. In doing so, she has won admiration from directors as renowned as Steven Spielberg, Barry Jenkins, James Cameron and Jane Campion. She is the only director whose first three films have all been nominated for the Academy Award for Best Picture, and in 2024 she became the first American female director to be Jury President at the Cannes Film Festival.

OPPOSITE:
Gerwig as the endearingly chaotic Frances in *Frances Ha*.

RIGHT MIDDLE:
Gerwig and creative partner and husband Noah Baumbach attend the New York premiere of *Mistress America*.

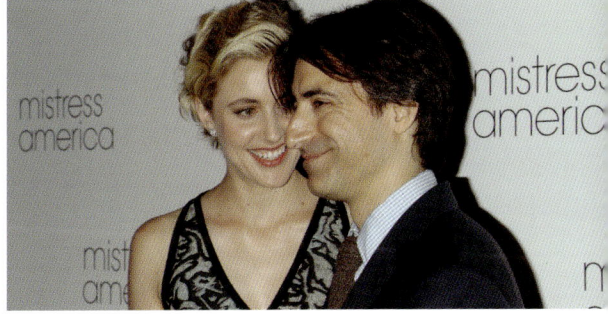

RIGHT BOTTOM:
Gerwig at the closing ceremony of the Cannes Film Festival 2024.

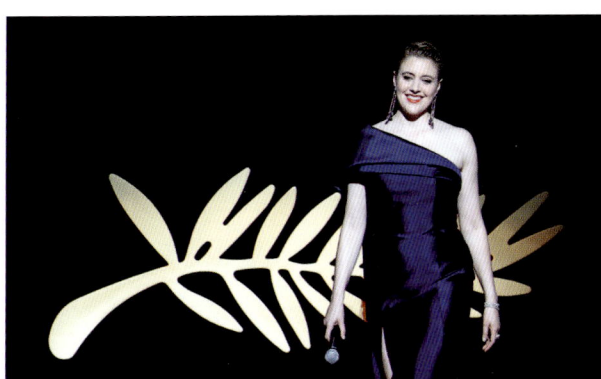

Sacramento

Greta Celeste Gerwig was born on Thursday, 4 August, 1983, not among the intelligentsia of New York City, nor in the dream factory of Los Angeles, but in the decidedly more humdrum Sacramento, California's state capital. Gerwig was one of three children and her mother Christine worked as a nurse while her father Gordon worked for a credit union offering small business loans.

But both parents maintained an artistic sensibility: Gordon would keep a record of his dreams, played jazz music and introduced his daughter to Monty Python, while Christine had an eye for repurposing secondhand clothing. They didn't approve of television or, funnily enough, of Barbie dolls. Gerwig has described herself as an energetic, enthusiastic child, a self-confessed bossy boots who in kindergarten tried to direct her own playmates in a production of Andrew Lloyd Weber's *Starlight Express*. She adored reading, and would've gone to ballet lessons all day every day if her mother had let her. Christine became worried about the cult-like intensity of her daughter's ballet teacher, so enrolled her in hip-hop dance classes instead.

Gerwig's biography will sound familiar to you if you've seen *Lady Bird* – she wove many of her early experiences into the script, from spending her teenage years in a post-9/11

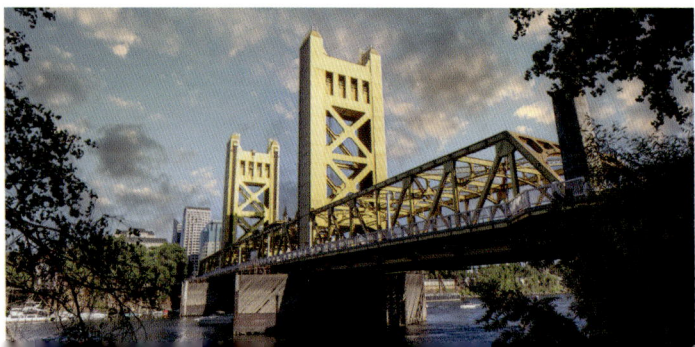

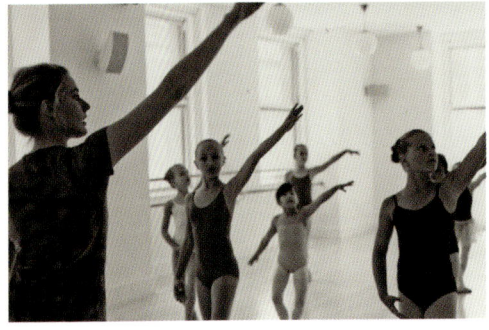

OPPOSITE BOTTOM LEFT: Tower Bridge in Sacramento, California.

LEFT TOP: Gerwig teaching ballet as Frances in *Frances Ha*.

LEFT BOTTOM: Saoirse Ronan and Laurie Metcalf in *Lady Bird*.

Sacramento, the idiosyncrasies of her Catholic high school, to her desire to escape the West Coast for college. She even revealed that she had her first kiss with a boy who eventually came out as gay – an experience Lady Bird has with Danny (Lucas Hedges).

But Gerwig is adamant that Lady Bird is not at all like herself at that age. Though she did have scorching rows with her mother, Gerwig was much more of a rule-follower at school, and she's admitted that Lady Bird is a braver alter ego, a girl who was more wildly herself than Gerwig ever was.

LEFT: Poster for *The Muppets Take Manhattan*.

OPPOSITE LEFT: Judy Garland as Esther Smith in *Meet Me in St. Louis*.

OPPOSITE RIGHT: Gene Kelly as Don Lockwood in *Singin' in the Rain*.

Gotta Dance!

Some of Gerwig's earliest and most meaningful experiences with film involved musicals. As a very small child she was taken to a rerelease of *The Muppets Take Manhattan* (1984) where she ran to the front of the cinema and tried to climb into the screen – she has said she's been trying to immerse herself in these fictional worlds ever since.

Her favourite film to this day is *Singin' in the Rain* – the genuinely iconic Technicolor spectacular released in 1952

which Gerwig first saw at the age of five. Growing up, her biggest celebrity crush was star Gene Kelly, which somewhat set her apart from her friends, though like every 90s girl she also loved Leonardo DiCaprio.

Her imagination was sparked, and she discovered other classic Hollywood musicals like *Meet Me in St. Louis* (1944), *An American in Paris* (1951), *Oklahoma!* (1955) and the films of tap-dancing screen legend Fred Astaire.

Rather than developing a passion for film, she initially aspired to be a ballet dancer or musical theatre performer. This was probably also thanks to occasionally accompanying her father on business trips to New York and London and being taken to Andrew Lloyd Weber's stage musicals. And yet the Hollywood musical would also come to be an enormous influence on her later film work, most especially the dreamworld of *Barbie*.

 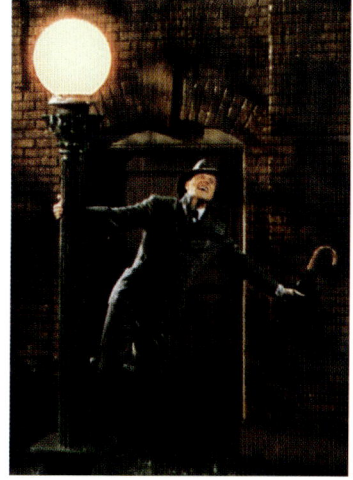

"I wanna go where culture is!"

Like Lady Bird, Gerwig dreamed of attending college on the East Coast and wanted to study musical theatre. But she quickly stalled: she was rejected from every acting college course she applied for, and her parents weren't wild about her pursuing something so impractical for such high tuition fees.

She eventually graduated from Barnard College at Columbia University in New York City with a degree in English and philosophy, but didn't abandon her love of the stage. She performed in an improv comedy group with future comedian, actress and *Saturday Night Live* cast member Kate McKinnon. Twenty years later, Gerwig would offer McKinnon the role of Weird Barbie, remembering the madcap musicals the pair devised together in college. It was also during her college years that she first discovered film as an art form.

Having graduated, Gerwig's plan was to gain a master's degree in playwriting, but again she was rejected from all the programs she applied for. Though she was dismissed by the academic side of the arts, she didn't give up. Like many of her heroines, she would follow her path in her own way, with tenacity and sheer force of talent.

OPPOSITE: Barnard College, New York City.

ABOVE: Gerwig and Kate McKinnon promoting *Barbie*.

BELOW:
Gerwig as Mattie and Joe Swanberg as James in *Nights and Weekends*.

OPPOSITE:
Gerwig as Hannah and Mark Duplass as Mike in *Hannah Takes the Stairs*.

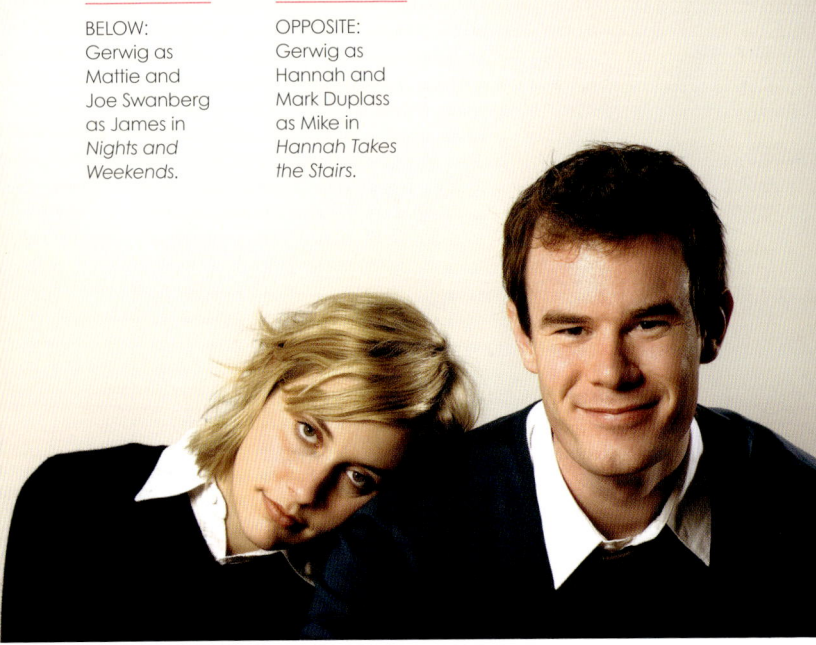

Mumblecore

In summer 2006 just after Gerwig graduated from Barnard she met filmmaker Joe Swanberg who was casting *LOL* (2006), his next indie project. Having been rejected from multiple playwriting programs the theatre world felt elusive to her, but here was an opportunity to make her small-scale cinematic debut via what came to be known as 'Mumblecore'.

The Mumblecore movement of the late 2000s was started by a group of young American filmmakers based on the East Coast. Working with minuscule budgets (*LOL* cost just $3,000), these films were loose, improvised and practically plotless. Shot handheld on cheap digital video cameras, they typically focused on the malaise of twenty-something college graduates falling in and out of friendships and relationships – very different from the old Hollywood spectacle Gerwig adored as a child. Nevertheless, she became the defining face of this unglamorous but influential micro genre, starring in *Hannah Takes the Stairs* (2007), *Baghead* (2008), *Yeast* (2008) and *Nights and Weekends* (2008) over the next two years.

Ti West, another friend of Joe Swanberg's, also cast her in *The House of the Devil* (2009), giving her a fabulously early 80s feathered hairstyle. West would later go on to direct A24 indie horror favourites *X* (2022), *Pearl* (2022) and *MaXXXine* (2024).

It wasn't exactly conventional stardom though. In the first few years Gerwig slept on a mattress on the floor in a shared bedroom in Brooklyn and paid the bills by working simultaneously as a nanny and a SAT tutor. As practically all actors have, she went through many dispiriting failed auditions, especially for longtime cop show *Law and Order* (1990 —).

ABOVE LEFT: Gerwig is menaced by a killer as Michelle in *Baghead*.

ABOVE RIGHT: Gerwig as the ill-fated Megan in *House of the Devil*.

Indie Stardom

Gerwig's breakout role would be in Noah Baumbach's *Greenberg* (2010) as the floundering but irrepressible Florence who falls for the jaded and much older Roger Greenberg (Ben Stiller). Though the film has an indie sensibility, its much higher budget, Los Angeles setting, plus co-stars like Stiller, Jennifer Jason Leigh and Rhys Ifans felt like a step towards mainstream success.

The film wasn't a commercial hit but her performance was critically acclaimed and the industry took notice of this bright young muse. Gerwig wasn't all that sad to leave Mumblecore behind for pastures new, as she has a love of the written word which doesn't align with the genre's improvisational approach. Plus, the shaky cameras made her feel queasy.

ABOVE: In *Greenberg* Gerwig plays naive personal assistant Florence to Ben Stiller's Roger Greenberg.

The credibility she'd earned thanks to her Mumblecore years in combination with her charming screen presence in *Greenberg* made her a true micro cinema darling. Over the next five years she would appear in films by highly respected arthouse directors such as Whit Stillman, Rebecca Miller, Todd Solondz and Mia Hansen-Løve. Watching these filmmakers work would eventually inspire Gerwig to pursue her own filmmaking career.

LEFT: Gerwig as Maggie and Ethan Hawke as John in *Maggie's Plan*.

BELOW: Gerwig as Dawn Wiener in *Wiener Dog*.

Hollywood

During the early 2010s Hollywood also came calling. Gerwig played the best friend role in the 2011 romantic comedy *No Strings Attached* starring Natalie Portman and Ashton Kutcher. Her most memorable scene features her on her period, morosely eating a cake and muttering that "It's like a crime scene in my pants". More regrettably, she appeared as quirky love interest Naomi in *Arthur* (2011) opposite Russell Brand, an almost universally disliked remake of the 1981 comedy starring Dudley Moore.

ABOVE: Gerwig plays Patrice, best friend to Natalie Portman's Emma, in *No Strings Attached*.

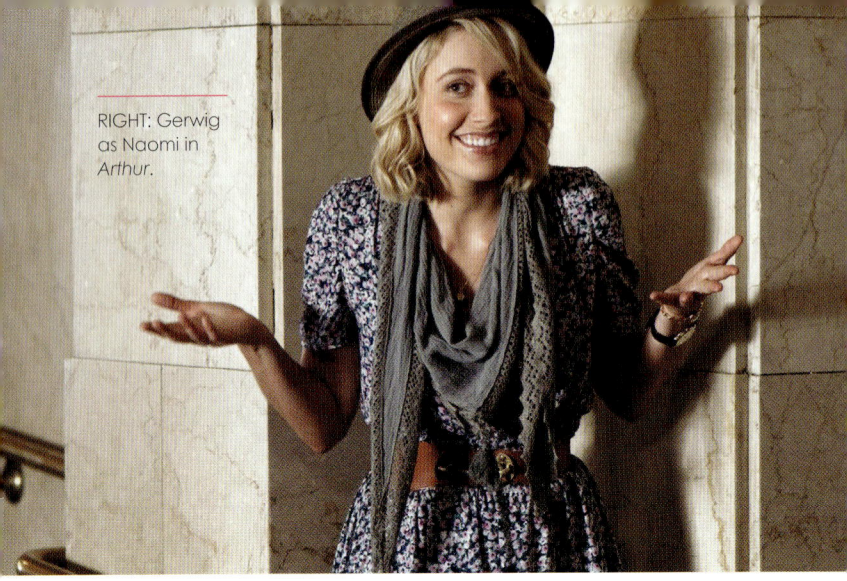

RIGHT: Gerwig as Naomi in *Arthur*.

There was one project that really could have taken her career in a different direction. In 2014 Gerwig starred in the leading role in the pilot episode of *How I Met Your Dad*, a spin-off of the incredibly popular sitcom *How I Met Your Mother*. Gerwig played Sally, a twenty-seven-year-old party girl, newly divorced and directionless in New York City.

Though Gerwig remembers the experience of making the pilot fondly, test audiences hated it and the show wasn't made into a full series. Although this must have felt like a major failure at the time, if the show had been a hit and Gerwig had been locked into a long-running sitcom, who knows if she ever would've become the beloved writer and director she is today?

OPPOSITE TOP: Baumbach and Gerwig present *Frances Ha* at the Berlin International Film Festival 2013.

OPPOSITE BOTTOM: Baumbach and Laura Linney on the set of *The Squid and the Whale*.

Greta and Noah

The most significant moment of Gerwig's early career was undoubtedly meeting writer and director Noah Baumbach, who would become her long-term creative partner and eventually her husband.

Baumbach was himself a well-established indie darling by the late 00s, having written and directed *Kicking and Screaming* (1995), and *The Squid and the Whale* (2005), which earned him his first Oscar nomination for Best Original Screenplay, and *Margot at the Wedding* (2007). He'd also co-written *The Life Aquatic with Steve Zissou* (2004) and *Fantastic Mr. Fox* (2009) with Wes Anderson.

Greta and Greenberg

Baumbach had been struck by Gerwig's performance in *Hannah Takes the Stairs*, and pointed her out to his agent who soon took her on as a new client. A few years later when he was casting *Greenberg*, that same agent recommended her for the role of lonely personal assistant Florence and she easily won the part. When she read the script, she had a realisation that Baumbach was the kind of writer she wanted to be herself, crafting dialogue that felt natural but slightly heightened, a rhythmic but emotionally real way of speaking.

Her natural liveliness and charisma is a much needed counterweight to the self-destructive cynicism embodied by Ben Stiller's Roger. She's also so effortlessly magnetic that

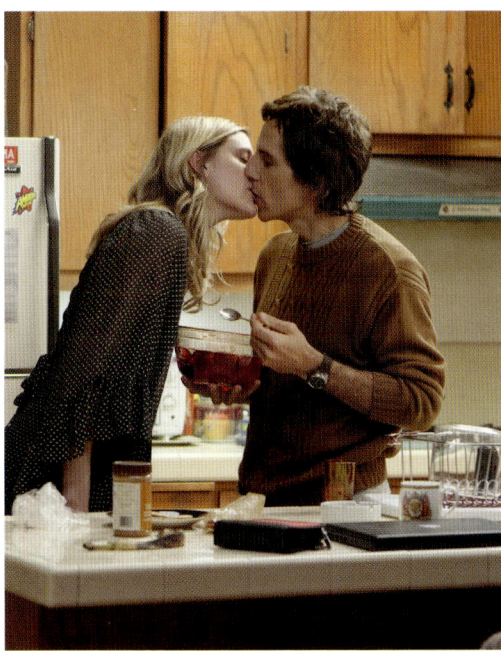

OPPOSITE BOTTOM: Gerwig in *Greenberg*.

LEFT: Gerwig and Ben Stiller in *Greenberg*.

it's easy to see why Baumbach fell in love with her, both on and offscreen. Who wouldn't be charmed by her delivery of lines like: "I was thinking this morning that I've been out of college now for as long as I was in, and nobody cares if I get up in the morning"?

Having loved working together on *Greenberg*, in 2012 Noah Baumbach cast Gerwig again in his television miniseries adaptation of *The Corrections*, the acclaimed novel by Jonathan Franzen. However, prestige network HBO, home of mega hits like *Game of Thrones* (2011–19), decided to shelve the project and the footage has sadly never seen the light of day.

Frances Ha

The pivotal collaboration with Baumbach that would come to encapsulate Gerwig's presence as an actress was *Frances Ha* (2012). It's also the project that really ignited her desire to write and eventually direct; Gerwig herself referred to the experience as realising she had a second heart beating inside her.

In what is undeniably Baumbach's best loved film, Gerwig plays the endearingly messy twenty-seven-year-old Frances Halliday, a struggling New York City dancer feeling isolated by her best friend's new relationship. And although the story has a certain melancholy feel to it (friends of Gerwig's who read the script felt it was almost overwhelmingly sad), her performance has such liveliness and humour that it seems to elevate Frances off the page.

Shot in gorgeous black-and-white and set to a soundtrack borrowed from French New Wave cinema of the 1960s coupled with songs by David Bowie and Hot Chocolate, it can be argued that over the past decade *Frances Ha* has become the defining film of the millennial generation. It's a slightly older 'coming of age' story, a touchstone for those in their late twenties who still feel lost while their peers are beginning to settle down with partners and/or excel in their careers.

OPPOSITE: *Frances Ha* poster.

Finding Frances

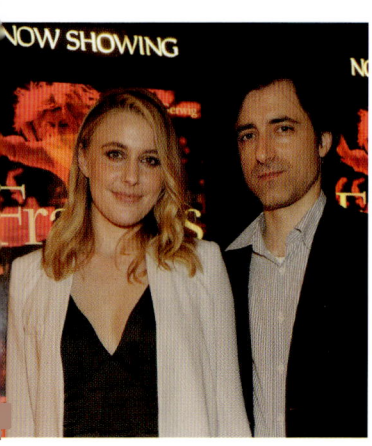

ABOVE: Gerwig and Baumbach attend a L.A. screening of the film.

OPPOSITE TOP: Frances (Gerwig) regresses by returning to her old college.

Gerwig and Baumbach developed the characters and story ideas together and eventually co-wrote the screenplay. They very rarely wrote in the same room, instead emailing scenes and ideas back and forth, a process she compared to writing music with another person with each of them on a different instrument.

Baumbach himself has said that many elements of Frances's personality are inspired by Gerwig: her sunny, casually insightful disposition, her big heart and her love of modern dance. The film wasn't written as a vehicle for her but he felt that the part was hers, and it's impossible to imagine anyone else as Frances.

Of course, the character and actress are about the same age, and much of Frances's post-college sense of being left behind was inspired by Gerwig's own experiences. She felt that in your early twenties you're permitted a grace period of being broke and all over the place, but by the time you hit your mid to late twenties, what was once charming now looks sadder and more desperate. Even for a successful actress like Gerwig, her twenties were a period of feeling like she was always teetering on the edge of failure.

When it came to embodying the character, Gerwig thought that she should have a distinctive physicality. A dancer who can't account for her own bruises, Frances is tall, awkward and a little bit of a clown. Gerwig uses big gestures and flourishes as she speaks, playing her as someone who instinctively flings herself forward but then suddenly retreats at the last moment, slightly too late. This is reflected in the group dance piece that Frances choreographs at the end of the film, a deliberately clumsy yet graceful performance which utilises falling and using the momentum to get back up. "I like things that look like mistakes," she says.

LEFT: Frances (Gerwig) devising her dance piece on an al fresco lunch break.

A Different Kind of Love Story

Initially, Frances and best friend/roommate Sophie (Mickey Sumner) are so close they resemble "a lesbian couple that doesn't have sex anymore," as their local coffee guy refers to them. The film opens with a montage of what looks like their perfect shared life in New York; freewheeling everyday adventures from play fighting in the park, to doing a load of laundry, to sitting on their windowsills smoking. They even share a bed, a vision of platonic soulmates.

Their friendship is the core of the film, practically its raison d'être. Unusually for a story about a young woman, romance isn't a key feature of the plot at all. The montage of Frances and Sophie is succeeded by a hilariously uncomfortable scene in which Frances's humourless boyfriend Dan (Michael Esper) tries to persuade her to buy two hairless cats together *and* move in with him. But she says she simply *can't* move in with him because she's committed to living with Sophie.

OPPOSITE: Frances (Gerwig) and Sophie (Sumner)'s last perfect day together.

ABOVE: Frances (Gerwig) and Sophie (Sumner) on their apartment balcony.

Her lack of enthusiasm for everything about him is even more obvious when Sophie suddenly calls her right in the middle of this passive aggressive conversation. Oblivious to his hurt feelings, she answers the phone in a silly voice and exchanges 'I love you's with her several times. Unsurprisingly, the scene quickly descends into a breakup – no boyfriend can ever compete with Sophie.

And though Frances has a hint of a will they/won't they with wannabe screenwriter Benji (Michael Zegen), the real romance is the platonic one between her and Sophie.

The sense of betrayal Frances experiences when Sophie moves out and begins a serious relationship with a preppy financier is far more painful than her actual breakup. "Don't treat me like a three-hour brunch friend!" Frances snaps at her, wounded by the realisation that her soulmate has someone else in her life now.

Frances Ha is where we begin to see the emergence of a filmmaker enchanted by the complex and loving relationships between women that are still underrepresented by the male-dominated film industry.

OPPOSITE: Frances (Gerwig) and new roommates Benji (Michael Zegen) and Lev (Adam Driver).

BELOW: Frances (Gerwig) spends too long in her parents' bath.

LEFT: Frances (Gerwig) is "not a real person yet".

OPPOSITE TOP: Frances (Gerwig) and Sophie (Sumner).

One Defining Scene: The Secret World

A chaotic presence at a noticeably grown-up dinner party with a group of thirty somethings, Frances is the only one not drinking wine but is the loudest and most conspicuous person in the room. Out of nowhere, she leans forward and describes her heart's desire to the woman sitting next to her who she barely knows:

"It's that thing when you're with someone, and you love them and they know it, and they love you and you know it…but it's a party…and you're both talking to other people, and you're laughing and shining…and you look across the room and catch each other's eyes… because…that is your person in this life. And it's funny and sad, but only because this life will end, and it's this secret world that exists right there in public, unnoticed, that no one else knows about."

She's effervescent with an intoxicated person's clarity, hazy and laser-focused at the same time. As she speaks, a delicate piece of music by Georges Delerue is gently introduced, the theme from French New Wave cult classic *The King of Hearts* (1966). The romantic flute, harp and piano guide us into her world of longing, and the strangers sitting around her fall under the spell too.

BELOW: Gerwig and Sumner attend the premiere of *Mud* in 2013.

At the end of the film her wish finally comes true. After her dance show, Frances and Sophie catch each other's eyes while talking to other people. It's magic: their gaze is tender, almost tearful, but also full of laughter and joy, their shared history written across their faces. The theme from *The King of Hearts* returns, signalling that despite their more separate lives, they are still each other's person.

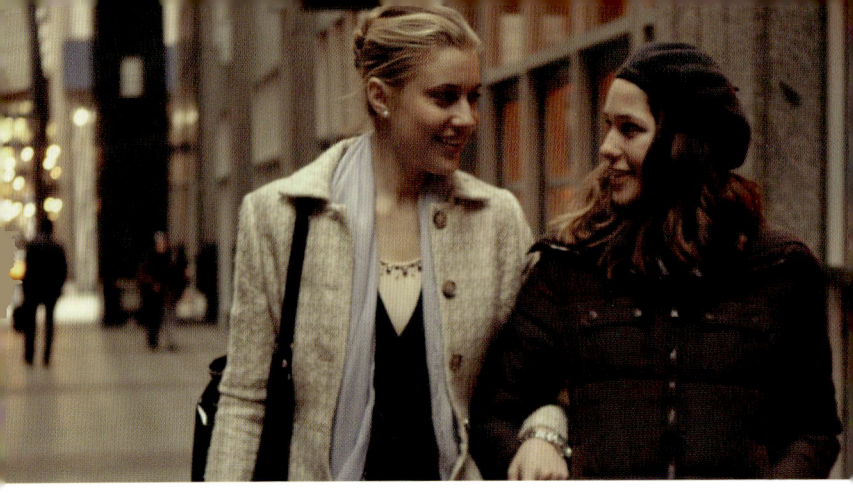

Mistress America

Having established a creative partnership and, during the making of *Frances Ha*, a romantic one as well, Gerwig and Baumbach went on to co-write another film with Gerwig in the lead role: *Mistress America*.

Tracy Fishko, an aspiring writer newly arrived in New York for college, struggles to fit in with her fellow students, let alone be accepted into Mobius, an elite literary society, with her short stories. At her mother's suggestion she contacts her only connection in the city: Brooke Cardinas (Gerwig), who is about to become her stepsister due to their parents' upcoming marriage.

Brooke is vivacious and energetic, a woman in her early thirties who's a kind of an NYC it-girl. She immediately

grants Tracy access to her glamorous milieu, and Tracy is spellbound watching her dance on stage with a band and entertain investors at a business lunch. She lives in a gorgeous mid-century style apartment with a wealthy Greek boyfriend who is always abroad, and has plans to open a restaurant in Brooklyn.

But it's also apparent that maybe every third thing that Brooke says is a lie, she has absolutely no follow through on any of her many ambitions and that she's working non-stop to maintain a facade. Fittingly for a film that references literature, Tracy narrating Brooke's life is reminiscent of F. Scott Fitzgerald's 1925 novel *The Great Gatsby*, in which the sparkling but hollow life of the titular millionaire is refracted through Nick Carraway's adoring perspective.

OPPOSITE: Gerwig's Brooke and Lola Kirke's Tracy in *Mistress America*.

BELOW: Gerwig as the luminous Brooke.

BOTTOM: Gerwig and Kirke attend the Sundance Film Festival 2015.

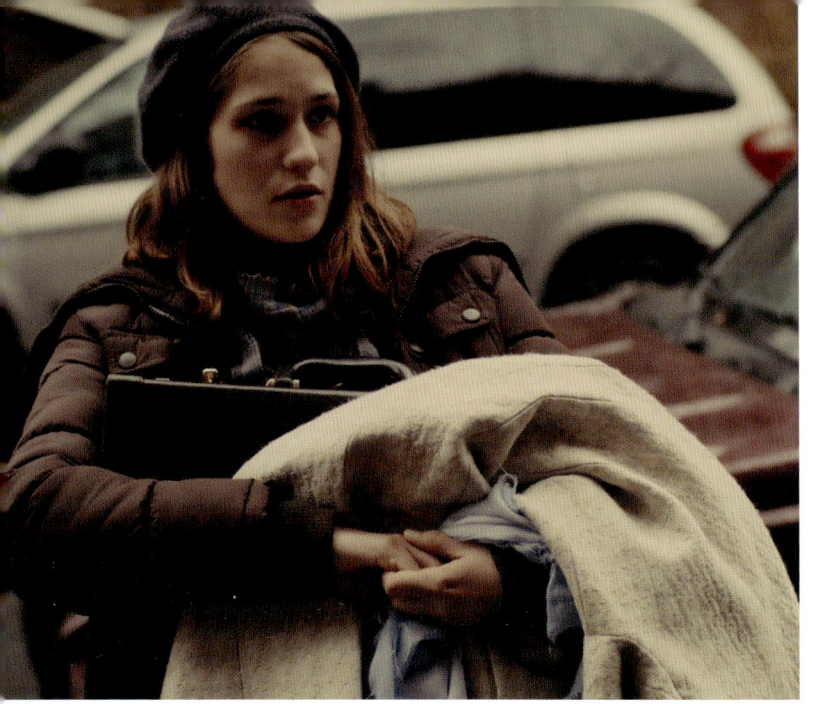

Mistress America acts like a kind of sister (or, more fittingly, stepsister) to *Frances Ha*. Both films are New York stories about ambitious young women, of course, with Gerwig's adopted home signifying a true city of dreams in her mind. But with its dual protagonists who are at two different stages of young adult life, she and Baumbach are able to draw parallels between the feeling of being driven but lost at aged eighteen, with your whole life ahead of you, and at aged thirty when it feels like certain paths are closed off for you.

This hardly sounds like a radical new direction for Gerwig, but the style of *Mistress America* is quite different. While *Frances Ha* was inspired by the French New Wave and has a

kind of loose, lived-in naturalism, *Mistress America* borrows from highly stylised screwball comedies of the 1930s and madcap 80s capers like *After Hours* (1985), *Desperately Seeking Susan* (1985) and *Something Wild* (1986). The dialogue has a kind of rat-a-tat-tat speed and rhythm that makes no attempt at realism.

OPPOSITE: Tracy (Kirke) is sometimes overwhelmed by Brooke's apparently glamorous lifestyle.

BELOW: Tracy (Kirke) and Brooke (Gerwig) visit a psychic for some guidance from the beyond.

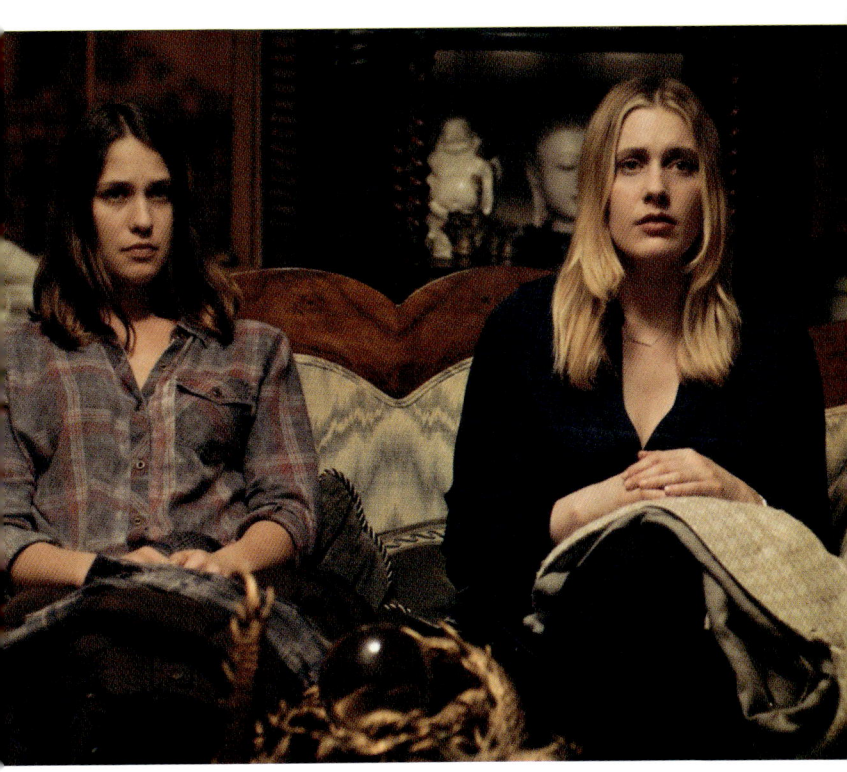

Brooke Cardinas: America's Heroine

Brooke originally existed as a much more minor figure in a different script Gerwig and Baumbach were co-writing. As is their routine, the two were reading the draft aloud to each other, and they both found Gerwig's performance as Brooke so funny that they decided to set this idea aside and develop a new script featuring the character as a lead. Brooke felt like someone they both knew already and simply leapt off the page.

In the films that inspired Gerwig and Baumbach, a larger-than-life character has an indelible impact on someone more ordinary or naive, usually over one crazy day or night. Although Tracy's adventures with Brooke aren't all that zany, Gerwig and Baumbach wanted to craft a character who feels like they just stepped out of one of those films. One influence was Katherine Hepburn as the eccentric and infuriating heiress with a pet leopard in *Bringing Up Baby* (1938).

ABOVE: Brooke (Gerwig) pitches her scheme to run a restaurant.

OPPOSITE TOP: Cary Grant and Katherine Hepburn in screwball classic *Bringing Up Baby*.

OPPOSITE BOTTOM: Tracy (Kirke) and frenemy Tony (Matthew Shear) in the halls of Barnard.

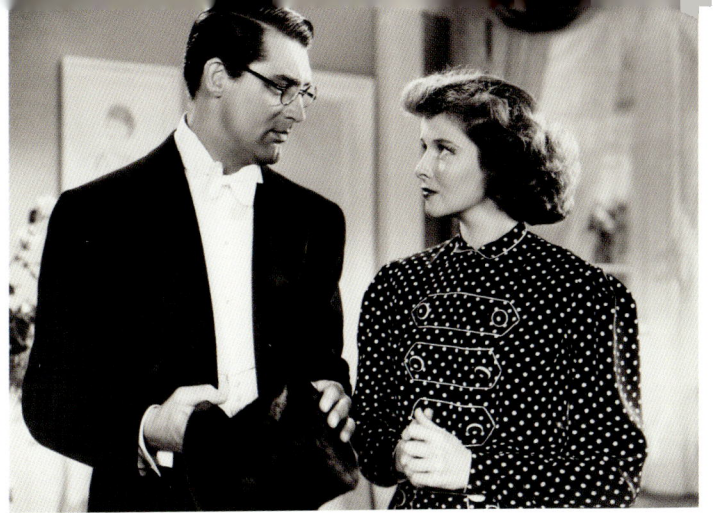

And Brooke is all performance, layers of which are stripped back as the film progresses. She's many things at once (socialite, spin instructor, interior designer, restauranteur) but isn't committed to anything much other than her own brand. Gerwig saw much more of herself in Tracy – she and Baumbach send her to Barnard College, Gerwig's alma mater, and even shot on the same dorm floor where Gerwig lived.

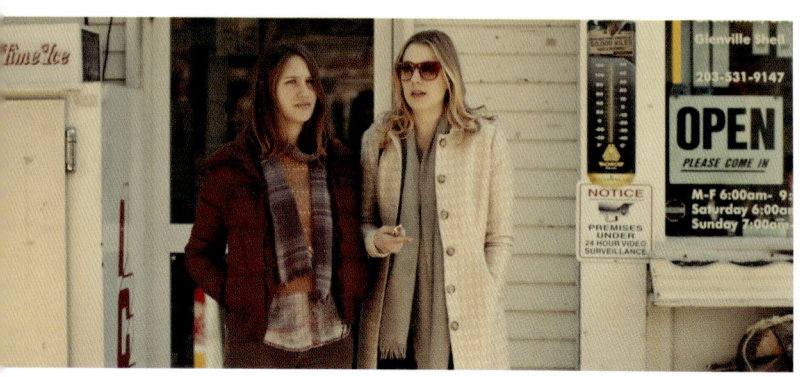

Brooke and Tracy

In *Mistress America* both Brooke and Tracy are striving to make their dreams come true and have contradictory but complementary relationships with status and success. To some extent they're both selling themselves in the same way.

A less interesting film would have Tracy be completely fooled by Brooke until the film's climax. Instead, she actually has a sense that Brooke's identity is made up of smoke and mirrors from their first meeting. Tracy appears to see Brooke as invulnerable, and fair game to be only lightly fictionalised in her writing. Yes, she's dazzled by Brooke's gal-about-town persona and wants to stay in her orbit, but she can smell her bullshit and that makes her all the more fascinating as a muse.

Tracy is playing a part too, that of a New York literary sophisticate in her beret and blazer. She's desperate to make it in to the exclusive Mobius writing society, the unfriendly members of which carry brown leather briefcases as a status symbol. Brooke's version of success looks like coiffed hair and silk shirts, but both young women wear different kinds

of costumes to project the life they want.

A codependency develops between the two, with each using the other's attention to feed their own ego: Brooke can be all-knowing, and Tracy can be her chosen protégé. Each has what the other wants: Tracy is drawn to Brooke's self-assurance and worldliness and Brooke is envious of Tracy's youth and intellectual intelligence.

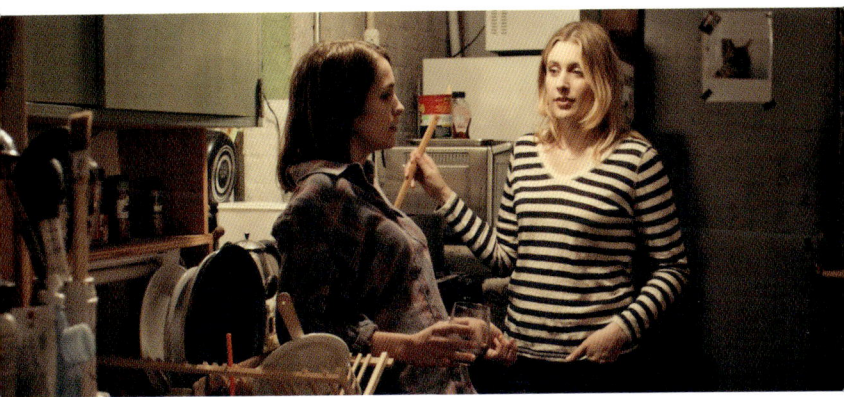

OPPOSITE TOP: Tracy (Kirke) and Brooke (Gerwig) on an ill-advised road trip upstate.

TOP: Tracy (Kirke) tries to settle in to Brooke's Brooklyn apartment.

ABOVE: Tracy (Kirke) and Brooke (Gerwig) are never on equal footing.

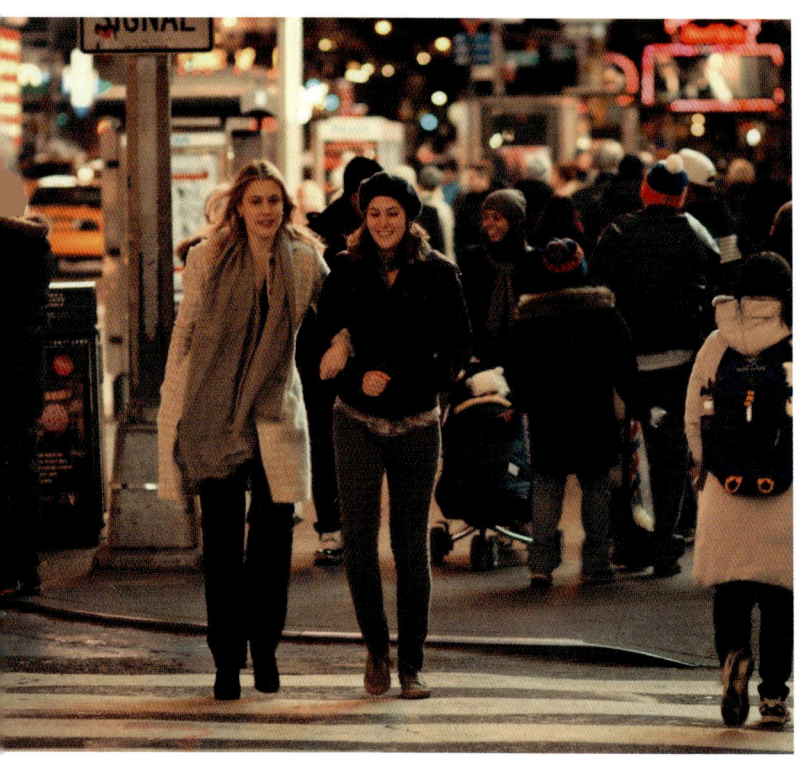

ABOVE: Brooke (Gerwig) takes Tracy (Kirke) under her wing.

One Defining Scene: A Whirlwind Night with Brooke

One evening Tracy is so lonely that she caves and contacts the soon-to-be stepsister that she's never met. Brooke makes a grand entrance at the top of the steps in Times Square, announcing "Welcome to the great white way!" before taking a comically long time to descend the stairs. It's as if

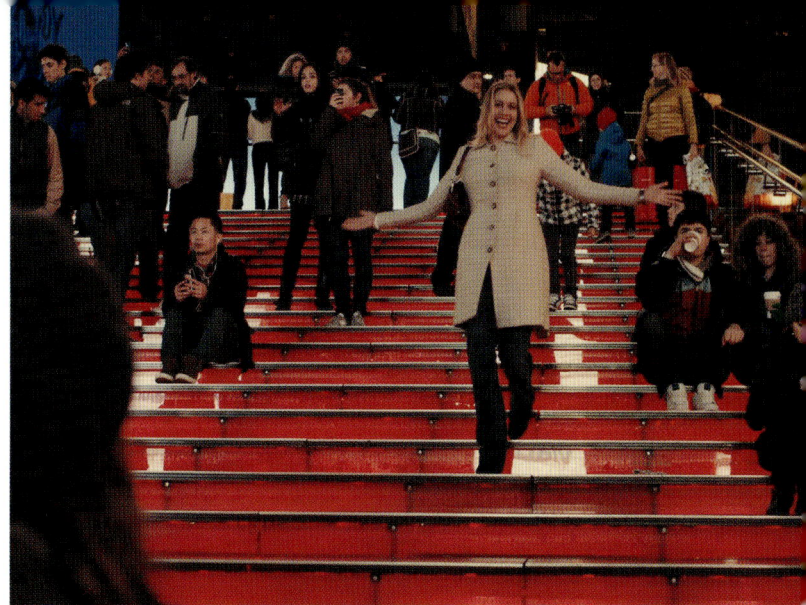

she realised just a little bit too late that this gesture wasn't going to work, but the show must go on. Brooke doesn't have the same tendency towards embarrassment that Frances has.

Soundtracked by Hot Chocolate's 'Could've Been a Lady', Brooke whisks Tracy away for a night of fun. A gig where Brooke dances on the stage turns into a bar with the band, then a house party, an Italian restaurant and finally her absurdly chic apartment. Throughout this montage she drops some classic Gerwig/Baumbach bons mots like "That's cool about the frozen yogurt machine. Everyone I love dies."

ABOVE: Brooke (Gerwig) tries to make an entrance in Times Square.

Over dinner, Brooke talks about an idea she had for a television show about a government worker by day who's a superhero by night and encompasses "...the essence of America. It'll be its own mythology. I think maybe it'll be called Mistress America." Here, in fact, is the essence of Brooke and the essence of the film itself. Brooke herself is America incarnate, embodying the culture of aspiration and individualism, of hustling, grifting and always looking ahead to the next goal.

Like the conclusion of *Frances Ha*, Brooke and Tracy don't exactly achieve their dreams by the end. But they both pick themselves up from disappointment and disillusionment and, like every Greta Gerwig heroine, they each find a new ambition to work towards having been fundamentally changed by knowing each other.

OPPOSITE: Brooke (Gerwig) impresses Tracy (Kirke) with her access to New York's hotspots.

TOP: Brooke (Gerwig), Tracy (Kirke), Tony (Shear) and his girlfriend Nicolette (Jasmine Cephas Jones).

ABOVE: Tracy (Kirke) and Brooke (Gerwig)'s last dinner together, finally understanding each other.

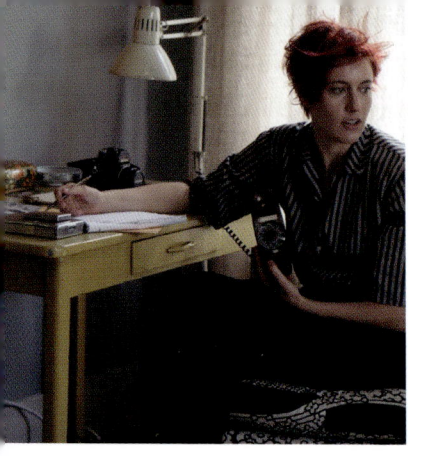

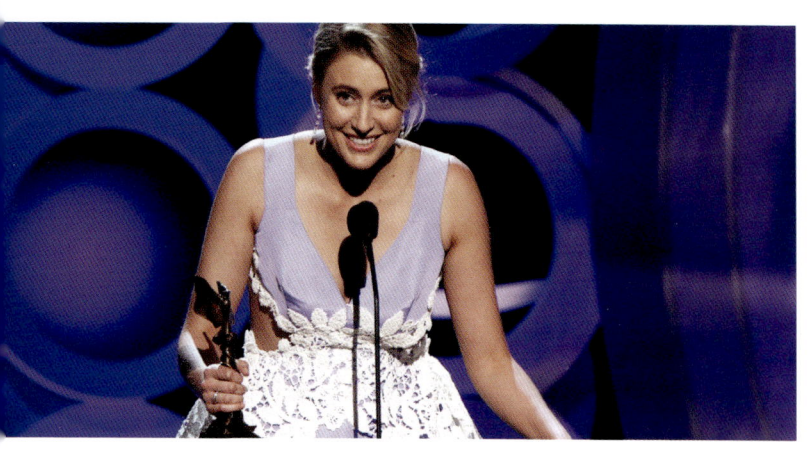

Greta Gerwig the Writer

Gerwig's move behind the camera was gradual but also seemed inevitable. Before *Frances Ha* and *Mistress America* she had gained writing credits on a few Mumblecore films, but primarily because of her improvised contributions rather than a clear intention to sit down and write a screenplay.

She has always seen herself as more of a writer than a director, and her love of hearing the written word spoken aloud by actors defines her relationship with cinema. Though improv was how she first made her name in the industry, working with filmmakers like Noah Baumbach made her realise that what she gravitated towards was dialogue that sounded so natural that it could be improvised, but is in fact very carefully written. She's called it 'accidental poetry'.

Before she met Baumbach, she had been writing continuously but never managed to finish anything; their work together seemed to unlock the process for her. The idea for *Lady Bird*, her debut as a solo writer, had been in her head for many years before she put pen to paper.

OPPOSITE TOP: Gerwig as photographer Abbie in *20th Century Women*.

OPPOSITE BOTTOM: Gerwig accepts Best Screenplay for *Lady Bird* onstage during the 2018 Film Independent Spirit Awards.

BELOW: Baumbach and Gerwig in New York in 2023.

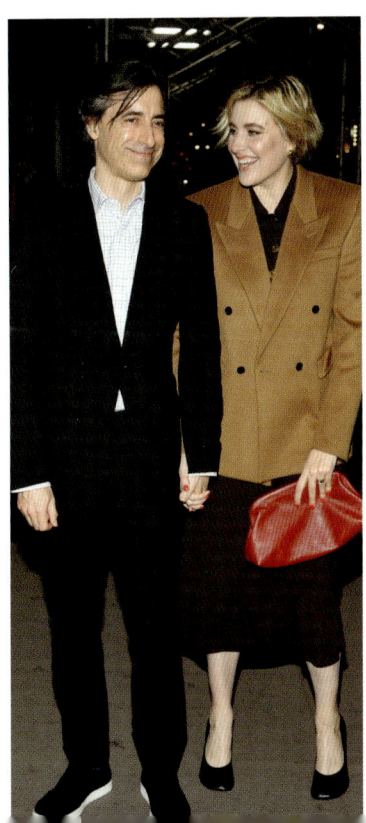

Fragments of Inspiration

Her process for every project, whether as intimate as *Frances Ha* or as spectacular as *Barbie*, begins with collecting snippets of inspiration – everything from overheard conversations to images from classic films she adores. For example, in one of the film's earliest scenes Lady Bird tells her mother "I wish I could live through something," a line that Gerwig stole from two teenage girls chatting on the New York subway.

Then it's a case of weaving all these small moments together and trimming the excess until she finds the core of the story, going through a huge number of rewrites. To do this, she emphasises the importance of not being wed to the very first version of a scene, no matter how much you might love it. Fundamentally she listens to her characters and when in doubt trusts that they will articulate who they are and what they need to do.

RIGHT: Joe Swanberg and Gerwig in *Nights and Weekends*.

Greta Gerwig the Director

Gerwig gained one co-directing credit during her Mumblecore years – she directed, wrote and produced *Nights and Weekends* with Joe Swanberg. The film follows a young couple, played by Gerwig and Swanberg, struggling to navigate a long-distance relationship and its eventual breakdown. Although it was improvised, the experience of crafting *Nights and Weekends* gave her an initial first-hand sense of how to construct a narrative and tell a story visually.

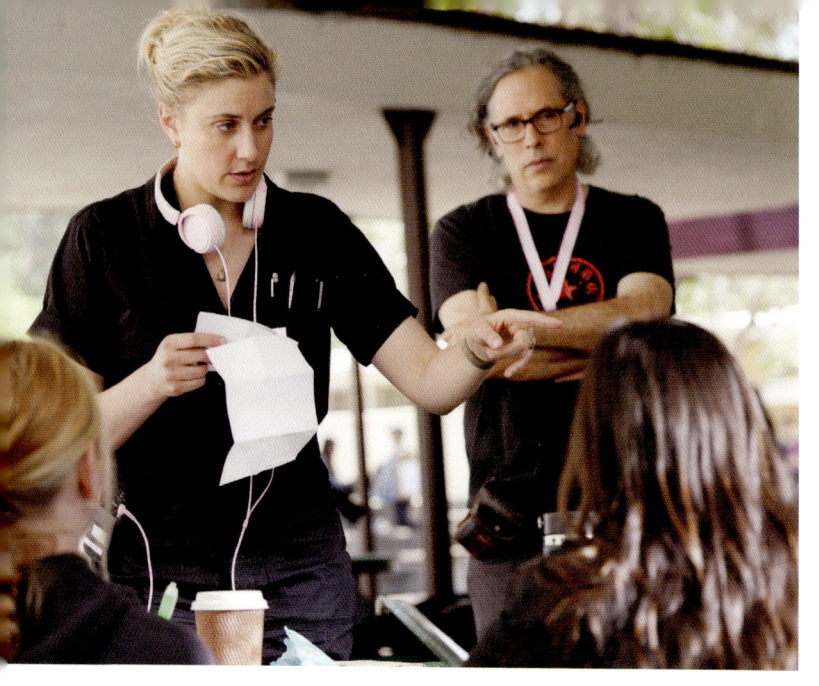

She had always wanted to direct a film by herself, but it was a desire she had suppressed for years. At five years old she attempted to direct her classmates in an amateur production of rollerskating musical *Starlight Express*, and at school she was teased for being bossy and a control freak. Growing up in the 1990s and 2000s, to be called ambitious was still practically an insult for girls and young women. Having never attended film school, Gerwig also felt that she didn't have the knowledge or experience she needed to become a director.

In watching French films, Gerwig had seen the director referred to as 'un réalisateur', or 'the realiser'. She felt more connected to this title than director, because it's about understanding that collectively, you and a crew of talented

individuals are 'realising' the film out of your imagination. Her ambition became to quite literally make the story real, while also ensuring that her sets would be friendly, warm environments where cast and crew alike would feel equal and safe.

OPPOSITE: Gerwig and cinematographer Rodrigo Prieto on the set of *Barbie*.

BELOW: Gerwig photographed for *The Washington Post* in 2019.

Inspirations and Encouragement

When she was becoming a cinephile in her college years, Gerwig fell in love with films by arthouse directors like Agnès Varda and Claire Denis. Watching Kathryn Bigelow become the first woman to win the Oscar for Best Director for *The Hurt Locker* (2008) felt like an assurance that one day Gerwig could do it too.

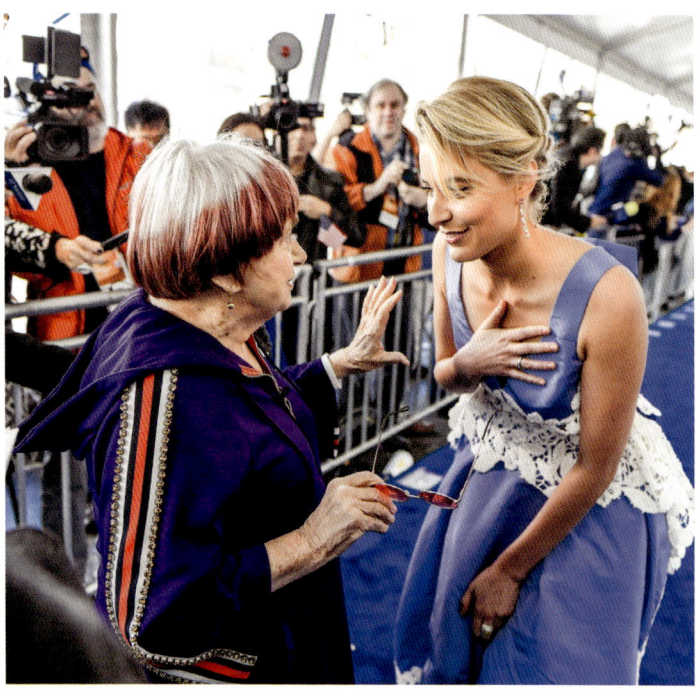

ABOVE: Gerwig meeting Agnès Varda at the 2018 Film Independent Spirit Awards.

OPPOSITE: Gerwig and Rebecca Miller attending a screening of *Maggie's Plan* in 2016.

Shortly after *Frances Ha* she happened to meet Sally Potter, writer and director of *Orlando* (1992), starring Tilda Swinton. Although she was asking Potter questions about her writing process, Potter astutely realised that here was a fledgling director. She encouraged Gerwig to ask about directing instead, and to let herself pursue what she really wanted. Gerwig has credited filmmakers like Potter and Rebecca Miller, who directed her in *Maggie's Plan* (2015), with giving her the courage to make the leap.

In writing *Lady Bird*, her first solo screenplay, Gerwig came to realise that even though the prospect scared her, this story was her vision and she wanted it to be wholly hers. And, of course, she had been spending time on sets for a decade, experiences that would act as her own film school.

She was ready to take flight.

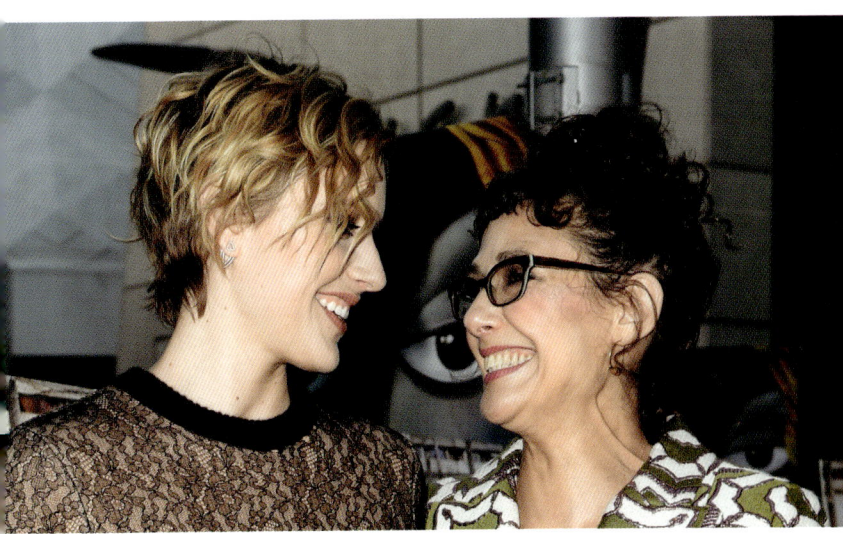

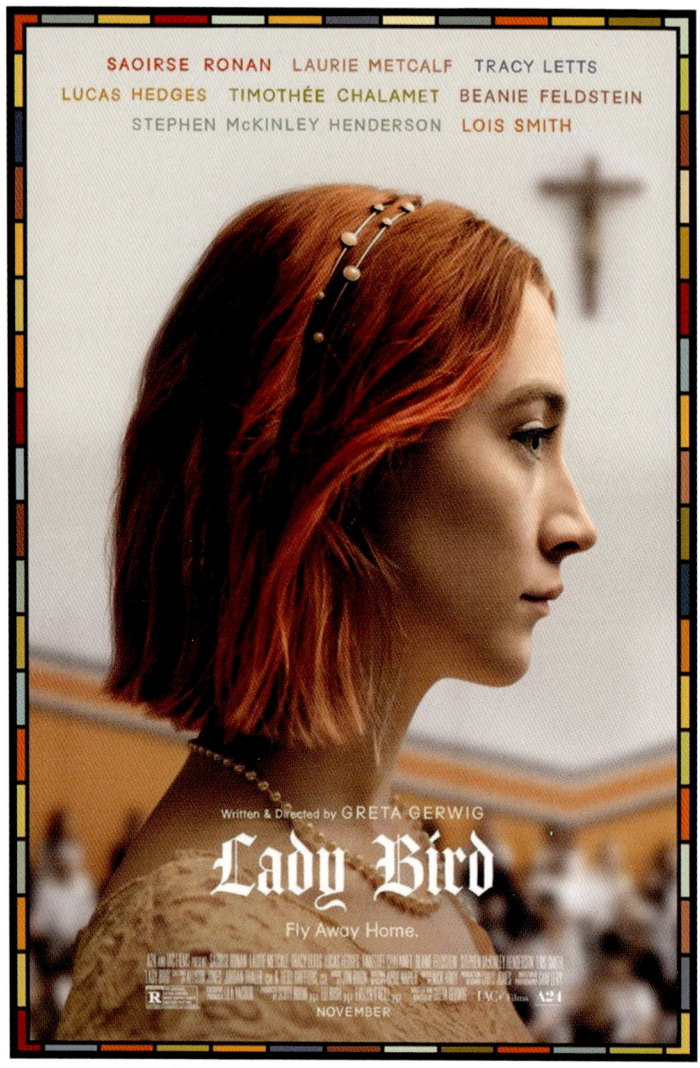

ABOVE: *Lady Bird* poster.

Lady Bird

BELOW: Marion (Metcalf) and her daughter Christine 'Lady Bird' (Ronan).

"The only thing exciting about 2002 is that it's a palindrome," sighs Christine 'Lady Bird' McPherson. At the beginning of a new millennium she spends her final year at a Catholic high school in northern California dreaming of an intellectual life at an East Coast college. But it's her tumultuous relationship with her mother Marion (Laurie Metcalf) that is at the film's heart. It's one that feels so complex and so real that it inspired women everywhere to pick up the phone and call their own mothers as soon as they left the cinema, even as men who saw the film couldn't believe that mothers and daughters really argue like that.

Gerwig has spoken about how so many women have experience projecting themselves onto stories about men because the overwhelming majority of stories, especially ones deemed important, are by and about men. She wanted to tap into the feeling of liberation for female audiences that comes from seeing their own lives reflected and, for once, not having to identify as a male character. Women watching *Lady Bird* could simply be themselves.

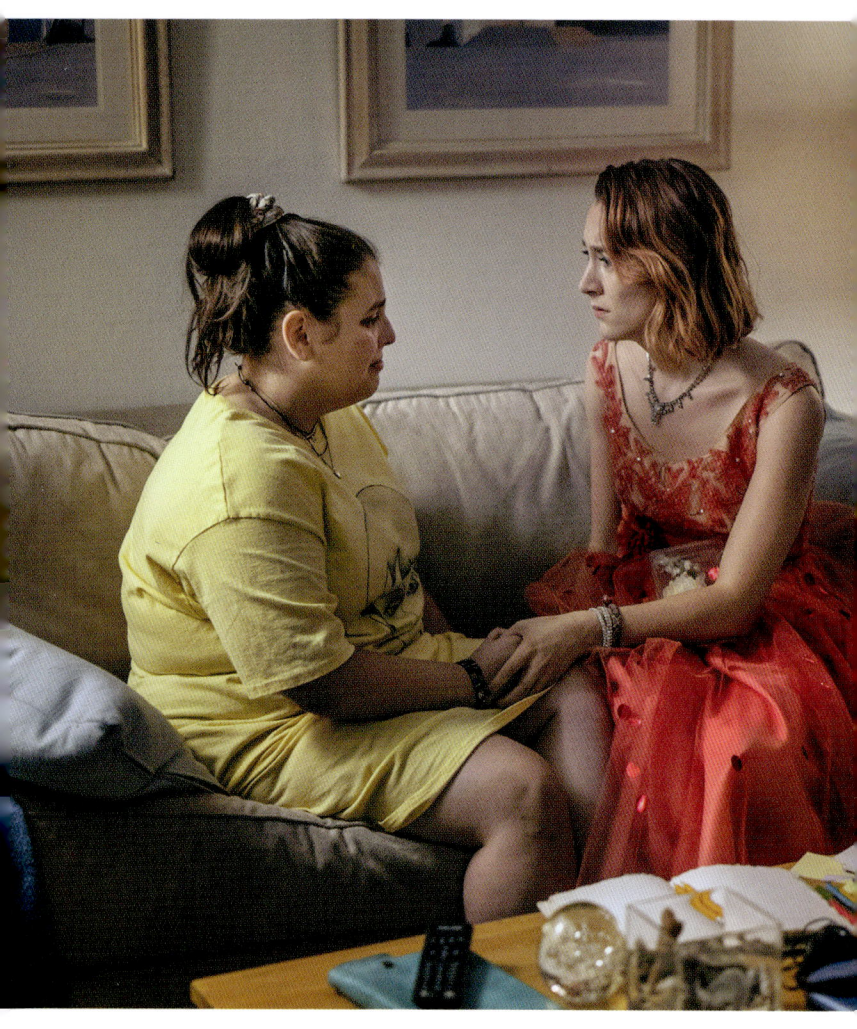

ABOVE: Lady Bird (Ronan) and best friend Julie (Beanie Feldstein) on prom night.

Gerwig tells the story in vignettes of both grand and small moments in Lady Bird's year. Using short chapters like this not only enables her to flesh out her world with loving detail and a sense of her characters' histories, it also mirrors the process of looking back on your own scattered memories of high school, of holding on to the fragments that form a life.

The story is populated by a host of brilliant supporting characters who all feel like whole, real people. They include sweet-natured best friend Julie (Beanie Feldstein) and teen boy lothario Kyle (Timothée Chalamet), to kindly nun Sister Sarah Joan (Lois Smith) and quietly suffering drama teacher Father Leviatch (Stephen McKinley Henderson). There are over 70 speaking parts in the film, and Gerwig was keen to capture the sense that daily life is shaped by relationships with a multitude of different people, whether big or small. As reflective and relatable as it is witty, it's a film that touched the hearts of millions all over the world.

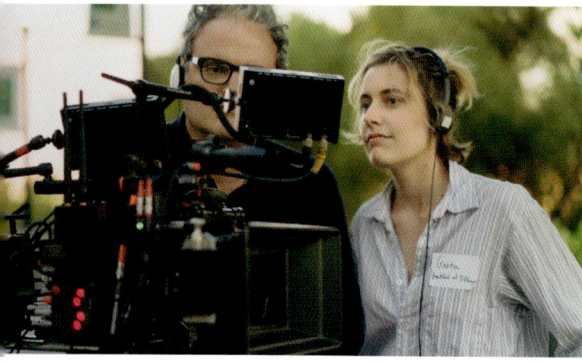

LEFT: Gerwig and cinematographer Sam Levy on the set of *Lady Bird*.

OPPOSITE TOP: Andrew McCarthy, Molly Ringwald and Jon Cryer in John Hughes's *Pretty in Pink*.

Conception

Gerwig's first draft of the screenplay that would eventually become *Lady Bird* dates back to late 2013. It was a whopping 350 pages. Traditionally, one page of a script equates to one minute of screen-time, so this would equate to a film about six hours long! Its original title was simply *Mothers and Daughters*, revealing the essence of the story which Gerwig had to find within the hundreds of pages as she edited and re-edited it down.

At one stage she had come to a dead end creatively, but suddenly she simply wrote the words 'Why won't you call me Lady Bird? You promised that you would' at the top of the page. This one line prompted her to ask herself who this girl could possibly be, and the writing process was unlocked.

And while Gerwig never dyed her hair red or asked to be called a different name, she has described the events in *Lady Bird* as emotionally true. Coming-of-age classics like *The 400 Blows* (1959) and *Pretty in Pink* (1986) were sources of inspiration, but these stories were either from a male

perspective or predominantly focused on a female protagonist looking for love. In crafting a flawed heroine who was braver than her younger self, she felt free to explore what personhood looks like for young women beyond romance.

Having lived in New York for over a decade, Gerwig felt most compelled to leave it behind and instead make a film that lovingly portrayed her native Sacramento. She begins the film with a brilliantly acerbic quote from another famous native of the California state capital, author Joan Didion: "Anybody who talks about California hedonism has never spent a Christmas in Sacramento." And what Gerwig really wanted to capture was a sense of rejecting the unexciting place that you're from while growing up, only to realise too late that it was actually beautiful all along.

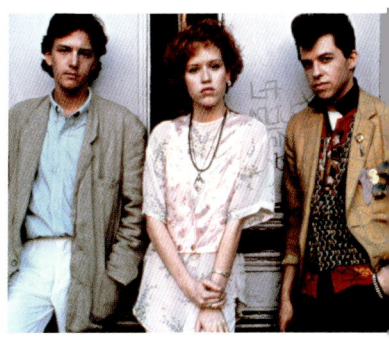

RIGHT MIDDLE: Jean-Pierre Leaud in *The 400 Blows*.

RIGHT: Joan Didion in 1981.

Casting

From her years as an actor and watching other directors, Gerwig had developed an intuitive sense of what makes an engaging performance and how to work with actors herself. Initially, she thought an unknown up-and-comer would

be best suited to play Lady Bird. But at the suggestion of producer Scott Rudin, she met with Saoirse Ronan at the Toronto International Film Festival in 2015.

She had first been wowed by Ronan's performance in *Atonement* (2007) when she was only thirteen. And although Ronan had been raised in Ireland and never attended an American high school, as soon as Gerwig heard her read the lines she felt like a third person had entered the room – Lady Bird herself. She describes Ronan's performance as having a 'lived-in' quality, of being so truthful it feels like you're watching someone experience something, not just perform it. Gerwig credits Ronan with being the co-author of the character of Lady Bird.

OPPOSITE: Saoirse Ronan in 2017.

ABOVE: Lady Bird (Ronan) seeks divine guidance.

An absolute powerhouse was needed to match Saoirse Ronan, and Gerwig chose the impeccable Laurie Metcalf to play Marion, Lady Bird's mother. An acclaimed stage actor and one of the stars of the much loved *Roseanne* (1988–1997), Metcalf brings depth and a kind of humane ferocity to this complex role, as well as exceptional comic timing. At the time Metcalf was also the mother of her own rebellious seventeen-year-old, so the role couldn't have come along at a more perfect moment.

Meanwhile Beanie Feldstein shines as Lady Bird's girly, long-suffering best friend Julie. Gerwig has said that while the primary love story in the film is between Lady Bird and her mother, the secondary is the one between the two friends. The importance of their relationship totally eclipses the boys Lady Bird pursues.

For indie boy idol Kyle, Gerwig spotted a young actor she saw in a play named Timothée Chalamet. With his pronounced cheekbones and mop of perfectly tousled curls he certainly looked the part of a teenage heartbreaker. Chalamet's intelligence also shone through, with Gerwig sensing that his fluency in French and Italian as well as his musical talent gave him a confidence that suited the role. She gave him stacks of books on socialism and economic theory to help him get a sense of Kyle's very male intellectualism.

RIGHT: Timothée Chalamet's Kyle was one of the young actor's breakout roles.

Other cast members include actor and award-winning playwright Tracy Letts as Lady Bird's father Larry, an immensely warm figure to whom Lady Bird is devoted. Laurie Metcalf had already known Letts for decades as part of the Chicago theatre scene, so the pairing felt like a natural fit. Lucas Hedges was another young breakout star of the film as the almost painfully adorable Danny, privately agonising over his sexuality. Having been floored by his performance in *Manchester by the Sea* (2016), Gerwig offered him any role that he wanted.

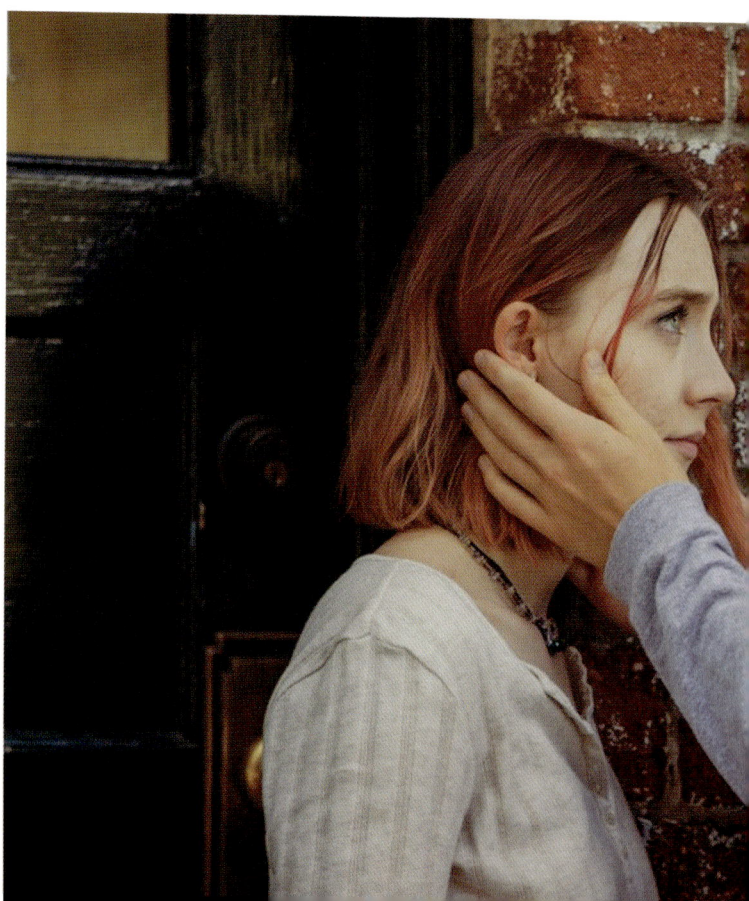

Rounded off with supporting turns from character actor veterans Lois Smith (nun and teacher Sister Sarah Joan) and Stephen McKinley Henderson (drama teacher Father Leviatch), Gerwig had the ensemble of dreams.

BELOW: Ronan as Lady Bird and Lucas Hedges as her closeted boyfriend Danny.

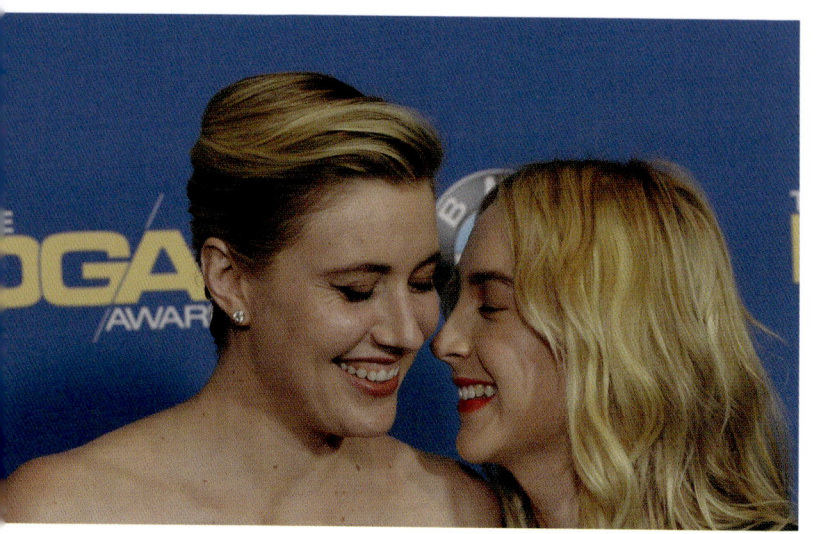

Greta and Saoirse

Lady Bird saw the beginning of one of Gerwig's most important creative partnerships, almost on the level of working with her husband Noah Baumbach. Ronan, who Gerwig affectionately calls 'Sersh', feels like an embodiment of Gerwig's creative voice. She, of course, has played two leading roles for her, Lady Bird and Jo March. Although her proposed cameo as one of the Weird Barbies in *Barbie* sadly didn't work out due to scheduling conflicts, Ronan is effectively the closest thing Gerwig has to a muse or a cinematic alter ego.

She's described working with Ronan as the two of them being in their own secret world, an endearing echo of Frances coming to understand the secret world she shares with her best friend Sophie in *Frances Ha*. She has

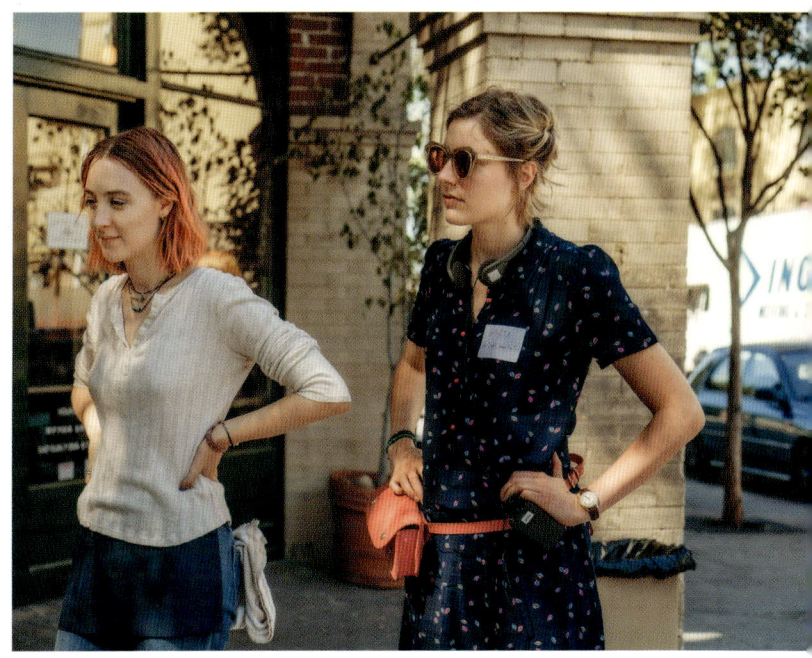

also found that Ronan is always searching for the truth in a scene or a performance, and that she can immediately recognise when she's been given a bad line, encouraging Gerwig to strive to be at her level.

Finally, and perhaps most importantly, Ronan says that working with Gerwig so closely has inspired her to start directing films herself, just as Gerwig has inspired aspiring female filmmakers all over the world.

OPPOSITE: Gerwig and Ronan at the Directors Guild of America Awards 2018.

ABOVE: Gerwig and Ronan on the set of *Lady Bird*.

Greta and Timothée

On *Lady Bird*, Gerwig not only discovered Saoirse Ronan, she was also enthralled by the talent of a young, relatively unknown actor named Timothée Chalamet, who takes his craft very seriously. His almost androgynous good looks appealed to her, being simultaneously handsome and beautiful, and a wonderful counterpart to Saoirse Ronan who also possesses a kind of masculine beauty.

Chalamet has a very different approach to acting to Ronan. While she likes to be told precisely what the goal of a certain scene is by a director and then pursue that, he prefers to take a character in unexpected directions and try alternative ideas on different takes. Their contrasting styles help to create an exciting atmosphere on set, and the pair have a natural but electrifying chemistry. Gerwig compares them to classic screen pairings like Humphrey Bogart and Lauren Bacall, and Gena Rowlands and John Cassavetes.

ABOVE: Lady Bird (Ronan) and Kyle (Chalamet).

OPPOSITE TOP: Gerwig and Chalamet attend the Academy Awards in 2018.

OPPOSITE BOTTOM: Ronan as Jo and Chalamet as Laurie in *Little Women*.

Gerwig has long held an ambition to create a company of actors she returns to again and again, in the style of filmmakers like Robert Altman and David Lynch. Along with Saoirse Ronan and Tracy Letts, who also appears in both *Lady Bird* and *Little Women*, she seems to be making her ambition a reality, and we can only wait and see if any of her *Barbie* ensemble make it into this illustrious club.

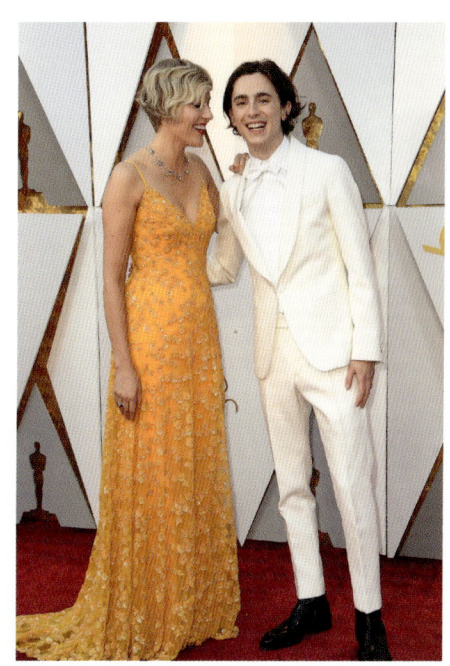

Cinematography

The guiding vision for the look and feel of *Lady Bird* was of captured memories rather than sheer realism. Gerwig initially wanted to shoot on physical celluloid film (Super 16, to be precise). As it's set in 2002 before the digital age had really taken hold, it would make sense to use celluloid to portray that moment in time. But Gerwig also wanted to use it because the hazy, somewhat imperfect image created by physical film also lends a sense of nostalgia, of looking back on your tumultuous high school years from adulthood.

Unfortunately, for budgetary reasons they had to shoot on digital, which is much cheaper and more practical to use

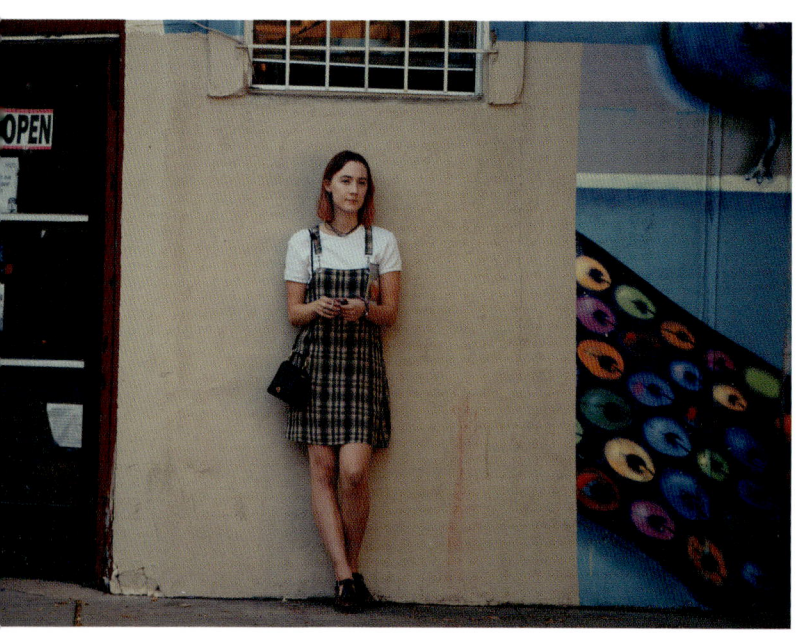

OPPOSITE: Lady Bird (Ronan) celebrates her 18th birthday with cigarettes and a copy of *Playgirl*.

BELOW: Gerwig on set in a prom dress.

than celluloid. But in collaborating with cinematographer Sam Levy (who also shot *Frances Ha* and *Mistress America*) Gerwig achieved an aesthetic that felt as textured and tactile as physical film minus the expensive inconvenience.

From the outset Gerwig also had an instinct to keep the camera as still as possible so the images felt composed and deliberate, rather than the sense of spontaneity offered by handheld cameras. As unlikely as it sounds, she was inspired by mediaeval triptychs and stained-glass windows, and how stories can be told in single static frames.

"Is it too pink?": Costume and Set

Costume designer April Napier, who later worked on *Booksmart* (2019) and *May December* (2023), had a challenge before her – how to bring Gerwig's vision of 00s Sacramento to life while also evoking a sense of timelessness. Lady Bird herself required over 90 costume changes alone.

In the screenplay Gerwig describes Sacramento as "the Midwest of California", a few years behind the latest trends.

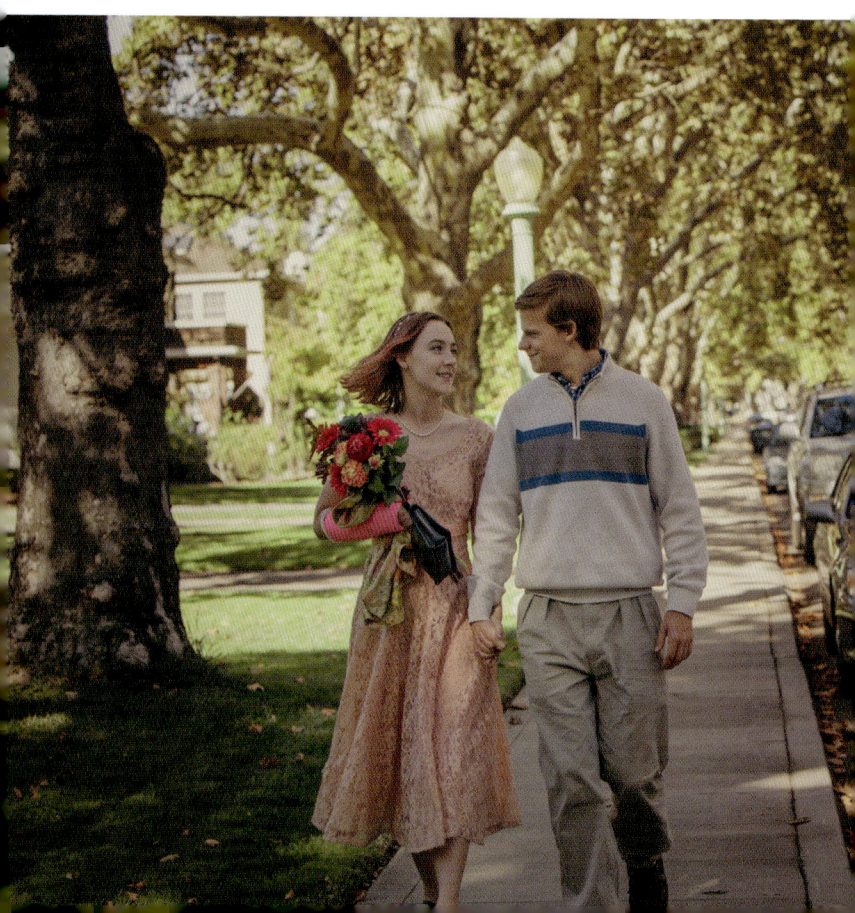

So in general Napier took more inspiration from the late 1990s than 2002 itself, flicking through Gerwig's own photographs and high school yearbooks.

In formulating Lady Bird's style, Napier knew that, as a rebellious teen formulating her identity, she would need to stand out from the crowd visually. She experimented with mixing clothes from the 50s all the way through to the 00s, as if the character didn't want to be tied down to one era.

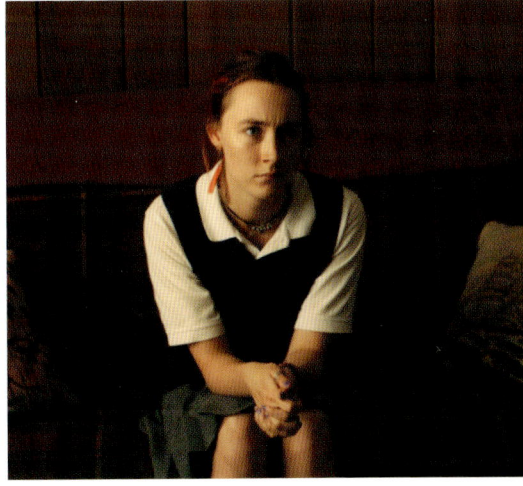

LEFT: Lady Bird (Ronan) wears a vintage 50s-style gown to meet Danny (Hedges)'s family.

ABOVE: Lady Bird (Ronan) starts wearing her hair in a ponytail to mimic the popular girls.

Her look also shifts throughout the film as she tries to find her place, mostly by imitating others. The vintage peach-coloured dress and pearl necklace she wears to Danny's respectable family Thanksgiving is a world away from the grungy, indie girl aesthetic she adopts to woo Kyle, and when she falls in with popular girl Jenna (Odeya Rush) she adopts the same preppy pink cardigan and ponytail.

Like all great costume design, every choice

BELOW: Lady Bird's parents, Larry (Tracy Letts) and Marion (Metcalf).

makes a statement about the character. For example, it felt right for earnest musical theatre nerd Danny to wear ill-fitting khaki trousers, and for sweet-natured Julie to sport tiny pastel hair clips.

Meanwhile, Marion wears bright colours and bold prints when she's not in her work scrubs, as if she is holding on to a more adventurous, artistic life that she once had and was forced to leave behind. Coupled with a haircut almost identical to Lady Bird's, the design encourages us to see mother and daughter as two sides of the same coin instead of opposing forces.

The most significant piece of set design was undoubtedly Lady Bird's messy bedroom, crucial for any coming-of-age story. Production designer Chris Jones felt that her room needed to show her personality and reflect the film's focus on the transitional period between childhood and adulthood. Working with set decorator Traci Spadorcia,

he collected pieces of furniture from the 80s and 90s that Lady Bird might have had as a child and held on to, like her white bed with a few pieces missing.

They decided on pink walls to further evoke childhood and act as a contrast to the muted, slightly sad brown of the rest of the house. They then covered those walls with countless bits and pieces, everything from album covers to her homemade 'VOTE LADY BIRD' posters. The final touch was leaving some of Lady Bird's actual costume items strewn around the room, as she's not the type of teenager to put her clothes away properly.

LEFT: The design and set dressing of Lady Bird (Ronan)'s home allows the audience to learn more about her family.

RIGHT: Gerwig directs Hedges and Ronan.

OPPOSITE: Ronan, Hedges, Feldstein and Gerwig.

Greta on Set

Gerwig has a profound love of actors, and one of her greatest joys is watching performances unfold before her eyes. The audience sees the final cut, but she gets the privilege of watching numerous slightly different versions of a line-reading, and seeing it live in front of her is like attending her own private play.

Over the years she has borrowed various ideas from other directors she had worked with to create a relaxed, professional but playful environment on set. For example, on *Lady Bird* she had everyone in the crew, including herself, wear a name tag. This was to help those who were only working on the film for a few days get to know everyone, as well as foster a friendlier and more equal working atmosphere. This idea was borrowed from Mike Mills, who directed Gerwig in *20th Century Women* (2017).

She encouraged the cast to get to know each other before shooting and to find a sense of fun and freedom, orchestrating hangouts in New York, as well as a period of rehearsals and dance parties two weeks before production started.

She also insisted on no smartphones on set as she finds them to be a distraction. She initially had to sell this to the young cast as a method acting technique, arguing that phones weren't an integral part of teen culture in 2002, and luckily her reasoning got them on board.

Score and Music

The soundtrack to *Lady Bird* is half its magic, taking its audience back to 2002 with humour and humanity. Gerwig had written all the songs she wanted to feature into the script, so for example Dave Matthews Band's soft rock naff classic 'Crash Into Me' was always going to soundtrack Lady Bird's heartbreak and her eventual reconciliation with Julie.

Gerwig felt such a strong need to include certain songs that she wrote letters to Dave Matthews, as well as Justin Timberlake and Alanis Morissette, asking their permission to use their work and explaining her personal connections to them. Thankfully, all three said yes.

Meanwhile, Jon Brion's score injects the film with a tender but bittersweet swell of emotion. He had scored some of Gerwig's favourite films of all time, such as *Magnolia* (1999), *Punch Drunk Love* (2002) and *Eternal Sunshine of*

the Spotless Mind (2004), and she had wanted him to compose the score from the very beginning. Brion relies mostly on woodwind instruments to capture a warm, wistful feeling without resorting to the melodrama of wailing strings.

OPPOSITE: Alanis Morissette in 1996, to whom Gerwig wrote a letter.

BELOW: Lady Bird (Ronan) in her school chapel.

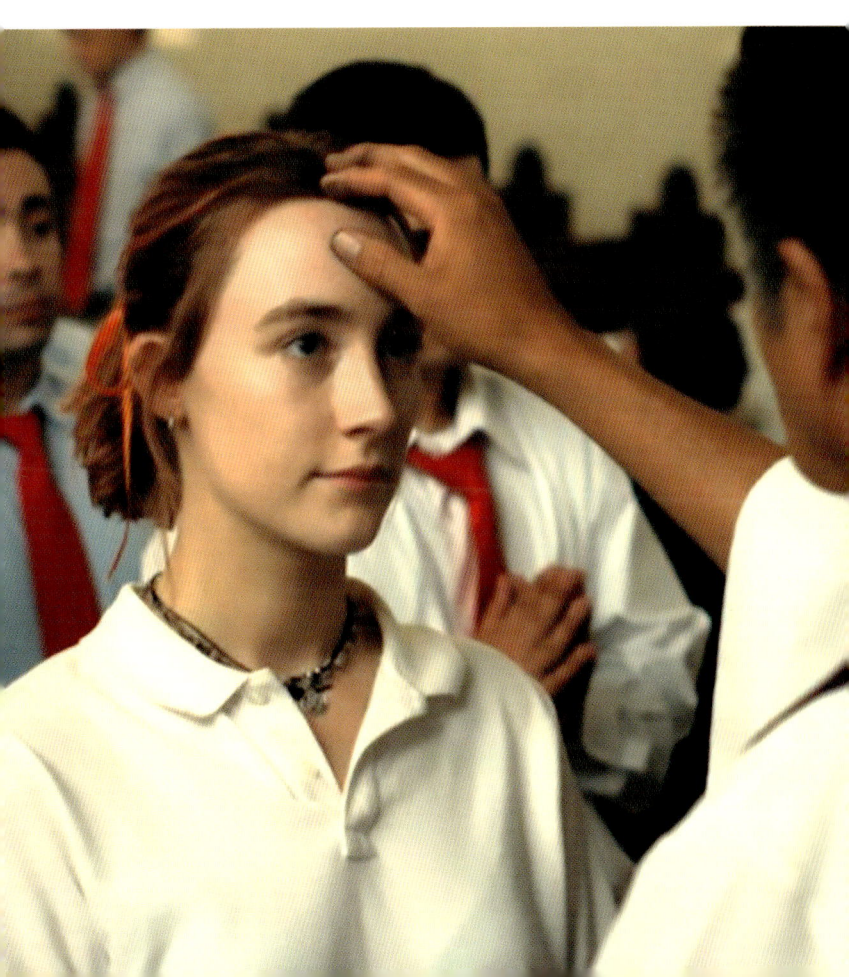

One Defining Scene: "Did you feel emotional the first time you drove in Sacramento?"

The film's most impactful scene is its final moments, which left audiences everywhere gently weeping. Lady Bird wakes up in a Manhattan hospital, having got blackout drunk the night before at a college freshman party. Her mother is so furious about her covertly applying for East Coast colleges that she's refused to speak to her, and now Lady Bird is alone in this new city.

Her mascara has run, leaving her with trails of charcoal tears down her cheeks. As she woozily sits up, she's confronted with the intense stare of an unsmiling boy sitting on another nearby bed, one eye concealed by a bandage. It's as if she's being observed and judged by an all-knowing higher power.

It's a Sunday morning, and she aimlessly wanders the sunlit New York streets until she stumbles on a church service. Inside, she's enraptured by the choir's singing, a reminder of her Catholic school back home. This moment illustrates that, despite all her eye-rolling and complaining, there was beauty and grace to be found there.

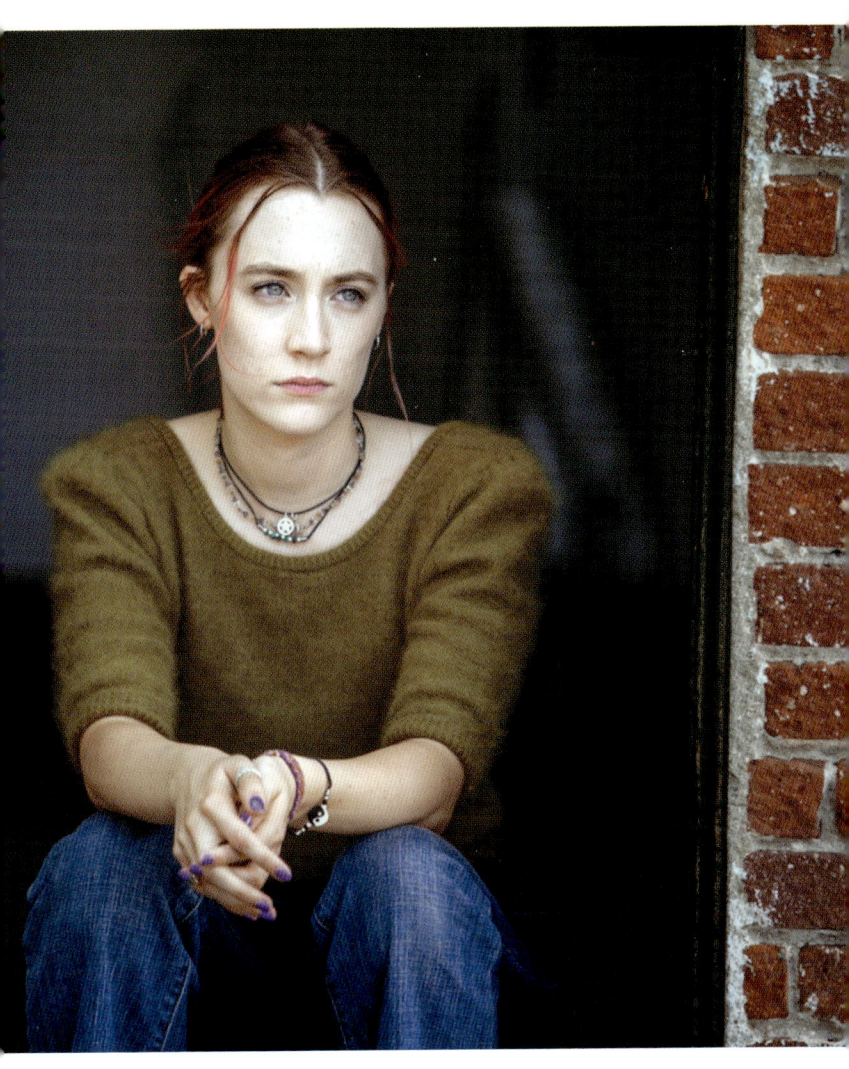

ABOVE: Lady Bird (Ronan) feels lost.

Having stepped outside, she leaves a voicemail for her mother, finally referring to herself with her real name, Christine. "Hey, Mom, did you feel emotional the first time that you drove in Sacramento?" she asks. "I did and I wanted to tell you, but we weren't really talking when it happened." As she speaks, Gerwig intercuts the scene with Christine driving through the city at sunset, bathed in a hazy glow, treetops, bungalows and diners passing by. As she

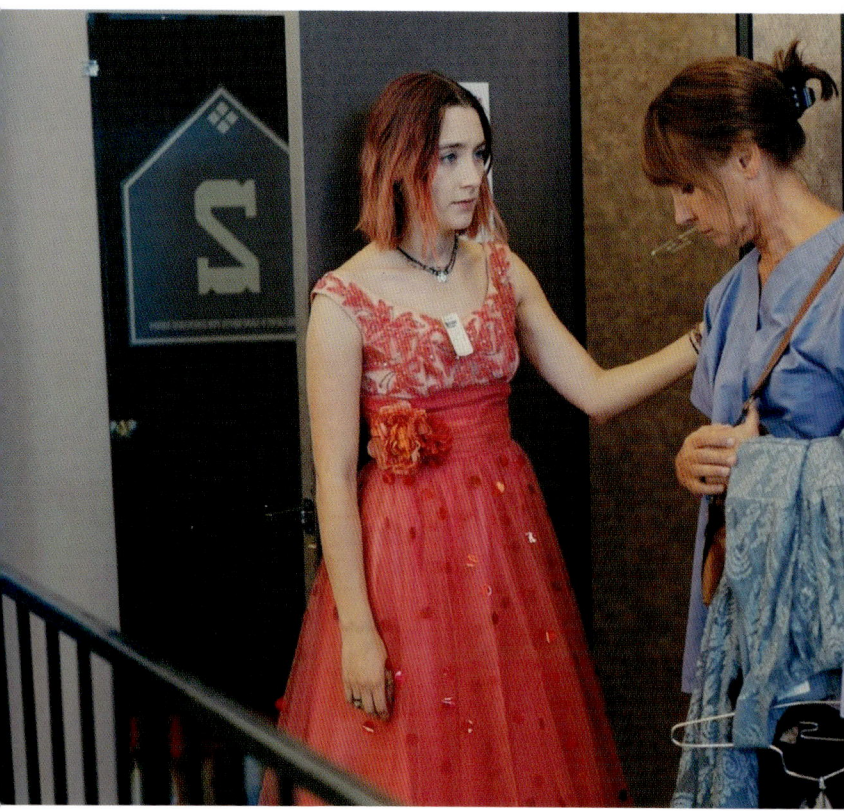

crosses a bridge, a close-up of her looking out over the river is intercut with Marion doing the same drive, the same look, the same small smile – it's heart-stopping.

In this intensely moving moment of union between Christine and Marion, Gerwig articulates visually what neither of them can put into words. Their connection is deeper and more profound than Christine ever recognised before. Her message to Marion in and of itself isn't a dramatic apology, she simply expresses her gratitude and understanding that her mother is a living, breathing, emotionally complex individual too.

Perhaps Christine's most crucial realisation over the course of the film is that everyone around her, especially Marion, has an interior life just as rich with triumphs and disappointments as her own. This is her coming of age.

LEFT: Lady Bird (Ronan) and Marion (Metcalf) share some hard truths.

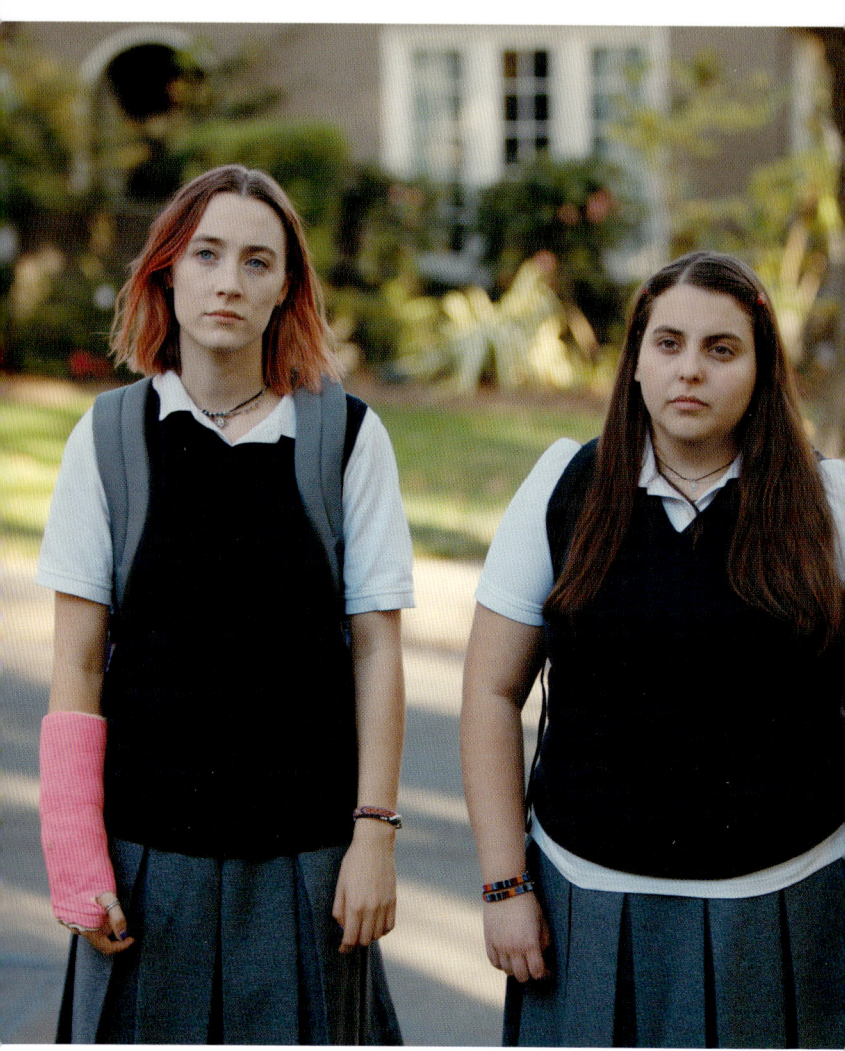

ABOVE: Lady Bird (Ronan) and Julie (Feldstein).

OPPOSITE: Gerwig on the red carpet having been named one of *TIME*'s 100 Most Influential People of 2018.

Time to Fly

Lady Bird was an indie sensation when it was released in the US in November 2017. Grossing a total of $78m against a budget of just $10m, it was a certified hit and A24's highest grossing film at that time. It was also almost universally critically adored, hailed as a sharp, funny and emotionally resonant instant classic.

It earned five Oscar nominations: Best Picture, Best Actress for Saoirse Ronan, Best Supporting Actress for Laurie Metcalf, Best Original Screenplay, and Best Director. Gerwig's nomination made her only the fifth woman to have been nominated for Best Director, and in 2018 she made it on to *TIME* magazine's list of the top 100 most influential people. The film is frequently cited as among the best films of the 2010s, and its success led to her helming an energetic, deeply felt new adaptation of one of the most beloved novels of all time.

Little Women

A determined young woman stands before a closed glass door. Her head is bowed, and she appears as a silhouette thanks to the light shining through the pane. Having braced herself with a moment of stillness, she enters what turns out to be a New York City newspaper's offices – all dark wood, full of men at their desks, a haze of cigar smoke. She has a short story for Mr Dashwood (Tracy Letts) – that is, her *friend* has a short story she would like to submit,

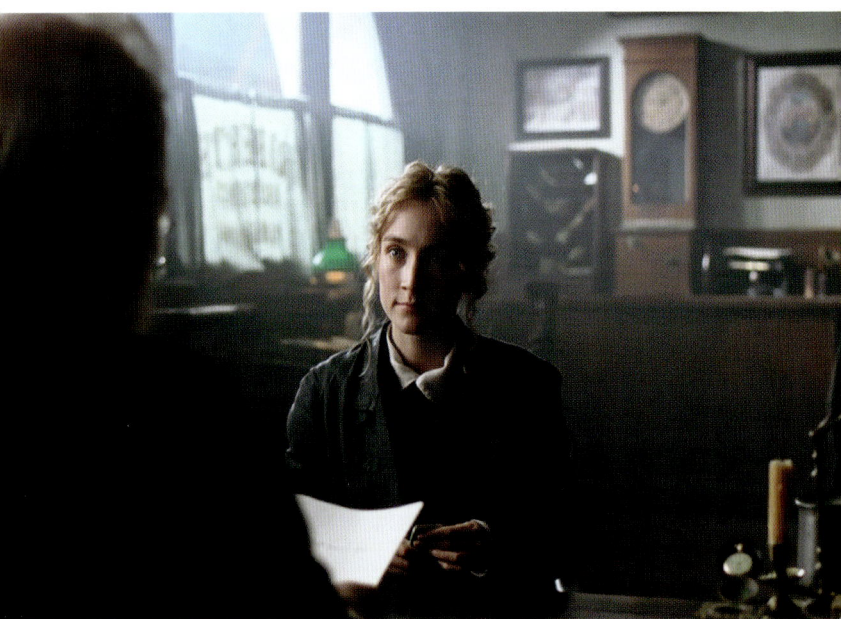

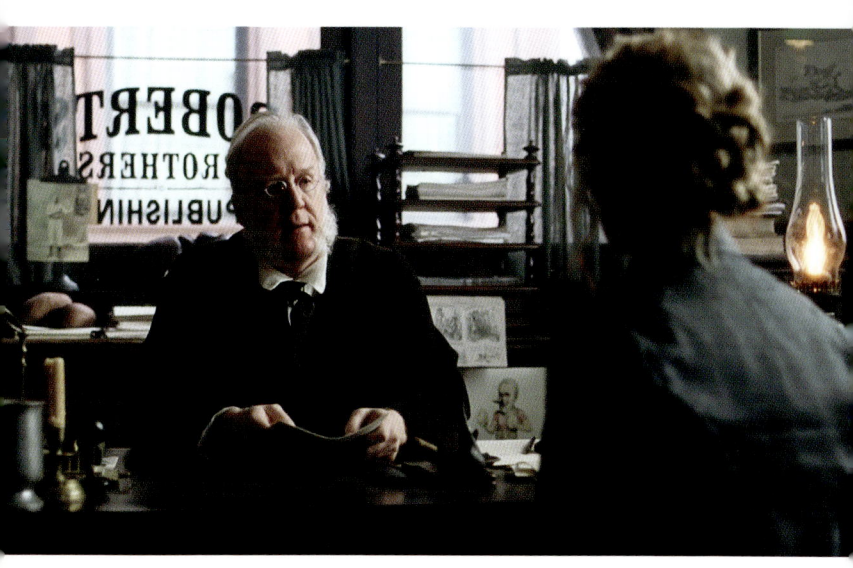

and this young woman is merely the messenger. But from the expression on her face and the close-up of her ink-stained fingers which nervously twitch while he's reading it, we know that this is her story. This, of course, is Josephine 'Jo' March (Saoirse Ronan).

Dashwood and Jo make a deal, and there's another close-up of hands, this time of Jo handing over the pages in exchange for cash. But Dashwood has a bit of commercial advice too: "If the main character's a girl make sure she's married by the end. Or dead, either way," he remarks, to Jo's raised eyebrows.

OPPOSITE: Jo March (Saoirse Ronan) sells her story.

ABOVE: Publisher Mr Dashwood (Tracy Letts) is sceptical.

A New Generation

Adapted many times before on film, television, the stage and more, Gerwig achieves what might have seemed impossible: she brings originality and vitality to one of the most beloved stories of all time. For many, the story of sisters Meg, Jo, Beth and Amy and their dearest Marmee simply *is* American girlhood. The novel was adored by generations of girls and women from its first publication as two volumes in 1868 and 1869.

Gerwig is a lifelong *Little Women* devotee. She can't recall exactly when she first encountered it as a child, nor can she remember a time when she didn't know who Jo March was. Her identity merged with Jo's: to this day she's unsure of whether she wanted to be a writer because of Jo, or if she

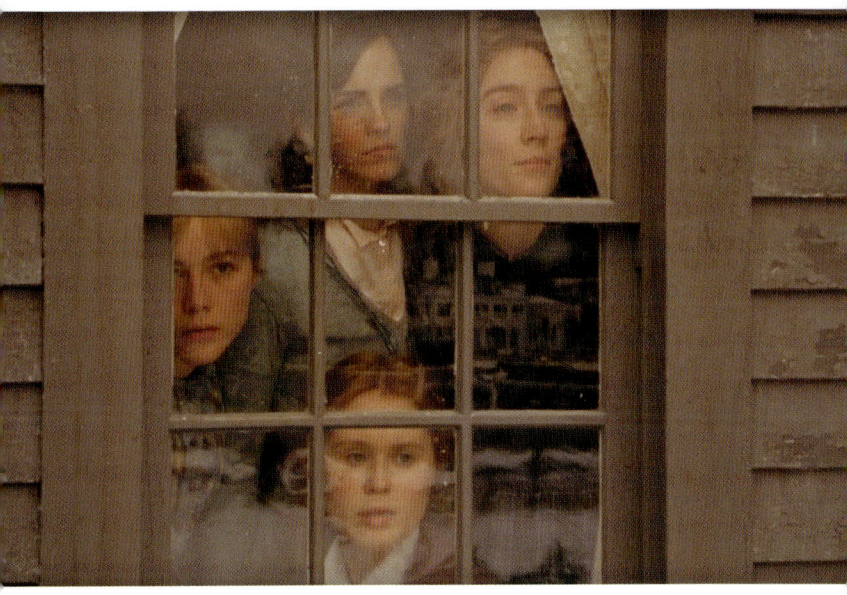

gravitated towards Jo because she already wanted to be a writer. She even went so far as to describe *Little Women* as her most personal film, more so than *Lady Bird*.

And as much as romance and marriage is part of Gerwig's version of the story, far more important is the closeness between the four sisters and their burgeoning selfhood, especially Jo's journey to becoming a writer. Gerwig saw it as a modern, remarkably relevant story about women's choices, and a new adaptation was an opportunity for this story to speak to a new generation.

OPPOSITE: Douglass Montgomery as Laurie and Katharine Hepburn as Jo in the 1933 adaptation of *Little Women*.

ABOVE: The March sisters in Gerwig's adaptation.

The Adaptation Process

Prior to *Lady Bird* Gerwig had heard on the grapevine that Sony was looking to make a new adaptation and begged her agent to get her a meeting. Thanks to the plaudits she'd received for her work on *Frances Ha* and *Mistress America*, Gerwig was hired to write it. But after the success of *Lady*

Bird she was offered the chance to direct the film as well, and leapt at the opportunity she'd been waiting her whole life for.

While she wanted to make the film feel urgent and contemporary, Gerwig also didn't want to stray far from the period setting or the text itself. Thankfully, in re-reading the book in her thirties she found it to be startlingly modern with its enduring themes of women's experiences of ambition, poverty, art and love. When she started working on the script, ensconced in a cabin in Big Sur, California, she found she barely needed to invent any lines of dialogue. Everything she needed was right there on the page already. For example, Amy's line "I want to be great, or nothing" is directly from the novel, even though it sounds like the kind of contemporary feminist rallying call you might see printed on a T-shirt.

ABOVE: Jo (Ronan) works on her manuscript night and day.

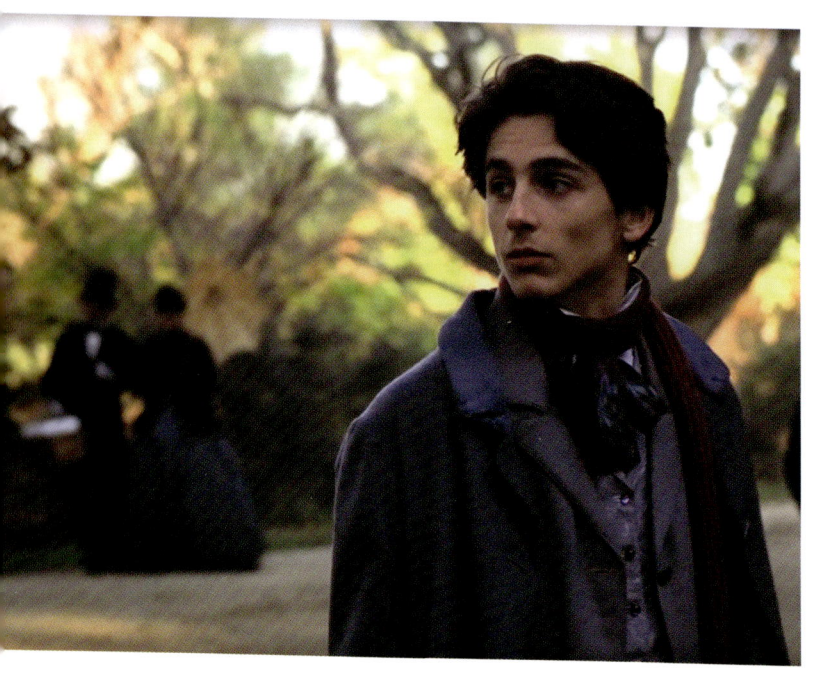

The most major and ingenious change Gerwig made was to the way the story is structured. Instead of moving through the story chronologically, she interweaves the first and second volumes of the novel. She introduces the March sisters first as young adults pursuing their dreams which is then intercut with their last years of girlhood in Massachusetts. This immediately sets the film apart from the many previous adaptations that tell the story more conventionally.

This bold restructuring also meant that certain inherent problems with the story, such as how to sell the audience on the marriages between Amy and Laurie and Jo and Professor Bhaer, an ending that remains contentious to this day, could

be handled by shuffling the order of events. For instance, Gerwig shows Amy (Florence Pugh) and Laurie (Timothée Chalamet)'s reunion in Paris at the very beginning of the film before we ever see Laurie meet Jo, meaning the seed of their love story is planted long before Laurie's doomed love for Jo is revealed.

It certainly helps that in this adaptation Friedrich Bhaer is younger and played by handsome French actor Louis Garrel.

OPPOSITE: Laurie (Chalamet) is enchanted by Amy all grown up.

ABOVE: Adult Amy (Florence Pugh) catches a glimpse of Laurie, observed by Meryl Streep's Aunt March.

Drawing Inspiration from Louisa May Alcott

For Gerwig, learning about Louisa May Alcott's own life and reading her collected writings was the key to unlocking the adaptation process. Many of the film's most impactful lines come from her letters and diaries in addition to the novel itself.

A strong-willed abolitionist and feminist all her life, Alcott came from a New England family that was much poorer than the Marches, but just as radical for their time. She and her mother and sisters were required to do gruelling manual labour to keep themselves afloat, and writing short stories for magazines was another means to make money. "I can't afford to starve on praise," she wrote after Henry James panned her first novel, a line that Gerwig gives to Jo.

It was her publisher, Thomas Niles, who suggested that she should write a story about young girls in the hope that such a novel would be a commercial success. She and her family needed the money but she was pretty reluctant to take

on his recommendation. She might have grown up as one of four sisters but she was a real tomboy and insisted she preferred the company of men and boys.

Nevertheless, Alcott managed to write *Little Women* in as little as three months, with Jo as her own fictional alter ego and her three sisters inspiring the other March girls. The novel was an instant hit, with the first printing selling out in two weeks, and the rest is history.

OPPOSITE: Portrait of Louisa May Alcott from the 19th century.

ABOVE: Louisa May Alcott's books archived at the American Antiquarian Society.

Louisa, Greta and Jo

Gerwig was struck by Louisa May Alcott's pragmatism and business sense. As she learnt more about her extraordinary self-advocacy, from negotiating a higher percentage of the profits from her publisher to keeping the copyright, her admiration for Alcott grew. She soon realised that this side of the author needed to be included in her screenplay. Jo March might have been Gerwig's heroine as a child, but Louisa May Alcott was her heroine as an adult.

In another radical departure from previous adaptations, she blended Jo and Alcott's identities, just as they were blended in reality. We see this in the scenes between Jo and Mr Dashwood, the newspaper editor and publisher. Gerwig highlights how important this is to her retelling by opening the film with Jo selling one of her stories to Dashwood, rather than the famous "Christmas won't be Christmas without any presents!" opening of the novel. In Gerwig's vision, Jo writes an autobiographical novel called *Little Women*, just as Alcott did.

OPPOSITE: Portrait of Gerwig in New York, 2019.

ABOVE: Ronan and Gerwig on the set.

Creating the March Family

As soon as Saoirse Ronan heard that Gerwig was working on *Little Women* she tapped her on the shoulder at an awards ceremony and stated that she was going to play Jo. At first Gerwig was hesitant to cast Ronan again but she also felt it was very Jo-like for Ronan to cast herself. After a day or so of consideration, the role was hers, and Timothée Chalamet became the natural choice to play Laurie.

Next to be cast was Emma Watson as eldest sister Meg, the most traditional of the March girls who has a talent for acting. Gerwig was impressed by Watson's warmth and intelligence and especially by her work with nonprofits advocating for women's rights. Her passion and insight made her ideal for a more contemporary incarnation of Meg.

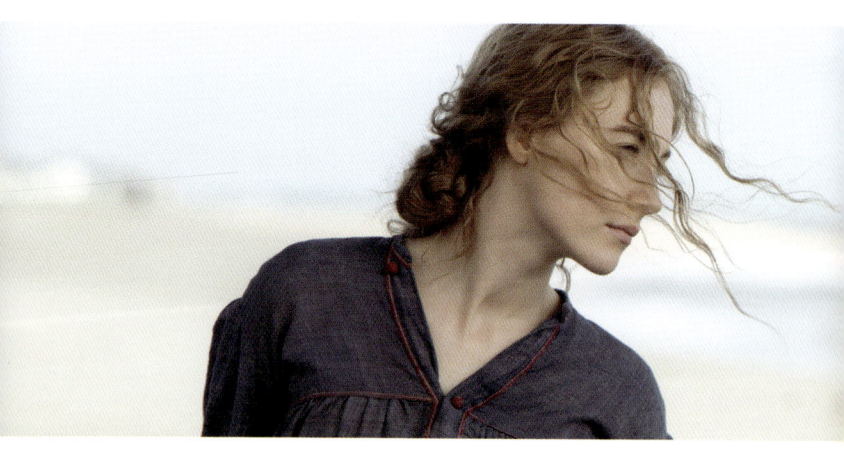

ABOVE: Ronan as Jo.

OPPOSITE: Ronan as Jo, Emma Watson as Meg, Eliza Scanlen as Beth and Florence Pugh as Amy.

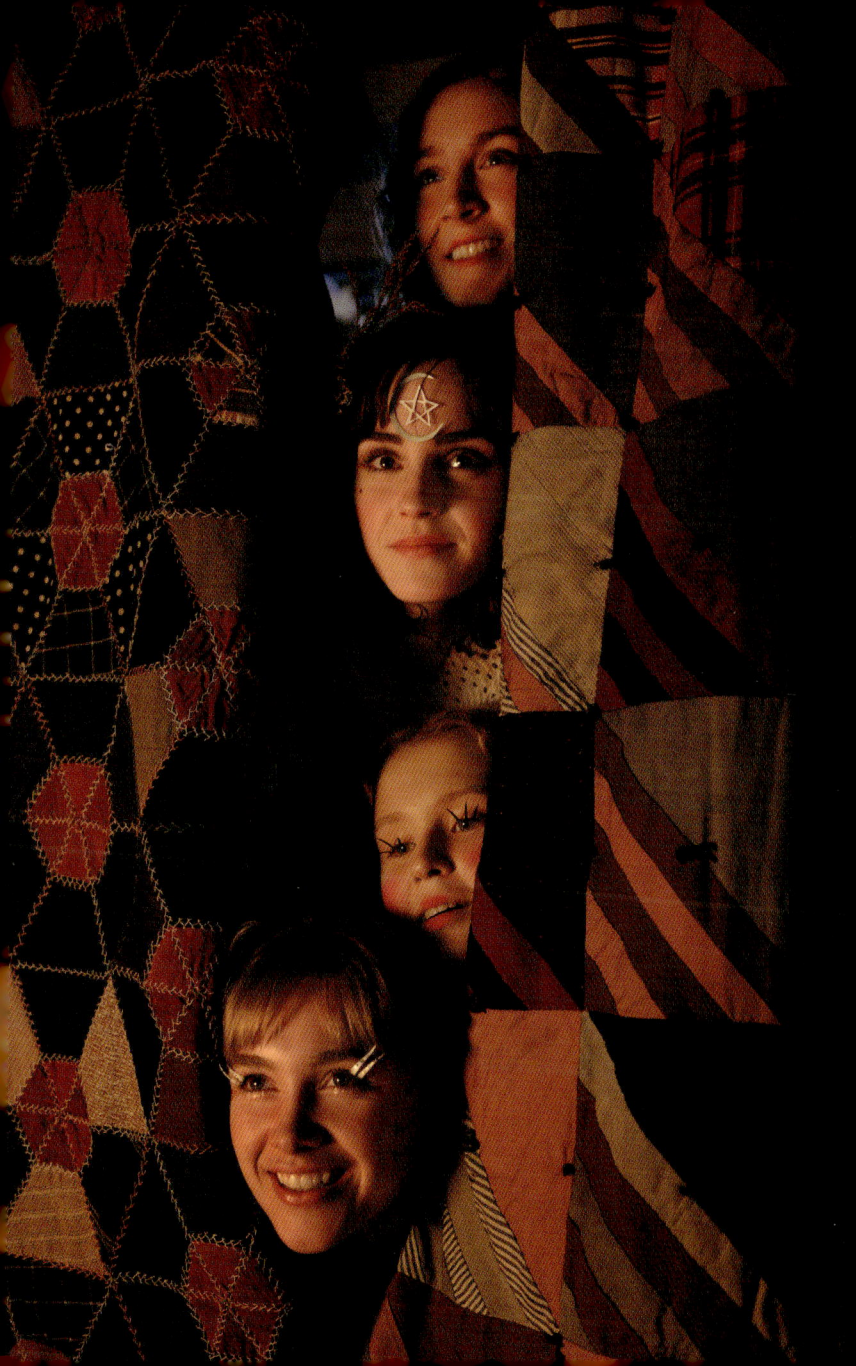

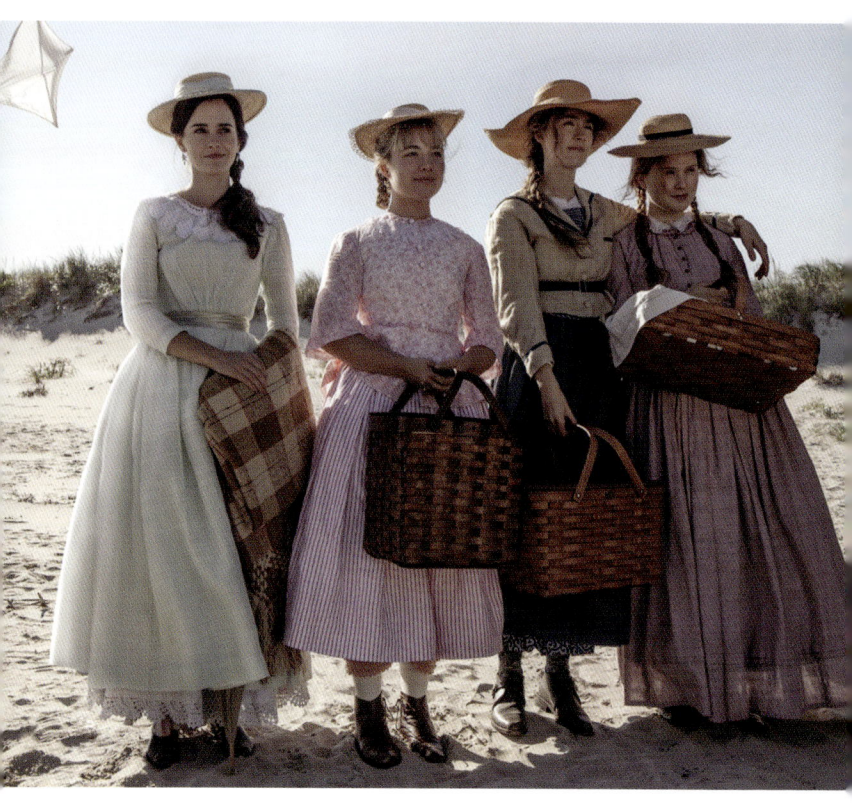

Then came Florence Pugh as Amy. Gerwig had been enthralled by Pugh's breakout performance in the acclaimed period film *Lady Macbeth* (2016), and knew she was a talented actress. But it was looking at photos of Pugh on red carpets that sealed the deal; her confident stance and her slightly upturned nose felt like the essence of Amy.

The final March sister to be cast was Eliza Scanlen as Beth. Scanlen had captured Gerwig's attention with her acclaimed

performance in TV series *Sharp Objects* (2018). Scanlen wowed Gerwig in the audition and together they developed Beth into a character who was a true artist and ambitious in her own way. Scanlen practised piano for three hours every day to make sure she would be convincing as an accomplished classical pianist.

The actresses formed a sisterly bond almost instantly. This shines through in the group scenes of the four sisters in which they're tumbling over each other and interrupting each other in a rhythm that Gerwig had carefully constructed. In fact, the actresses chattered and laughed so much off camera that Gerwig half-jokingly had a megaphone brought in, in an attempt to regain some authority over the chaos. Held together by the warmth and understated radicalism of Laura Dern's Marmee, the March family was complete.

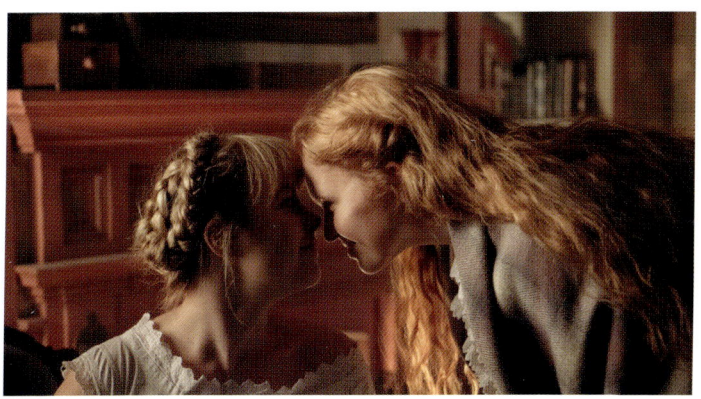

LEFT: Meg (Watson), Amy (Pugh), Jo (Ronan) and Beth (Scanlen).

ABOVE: Younger March sisters Amy (Pugh) and Beth (Scanlen).

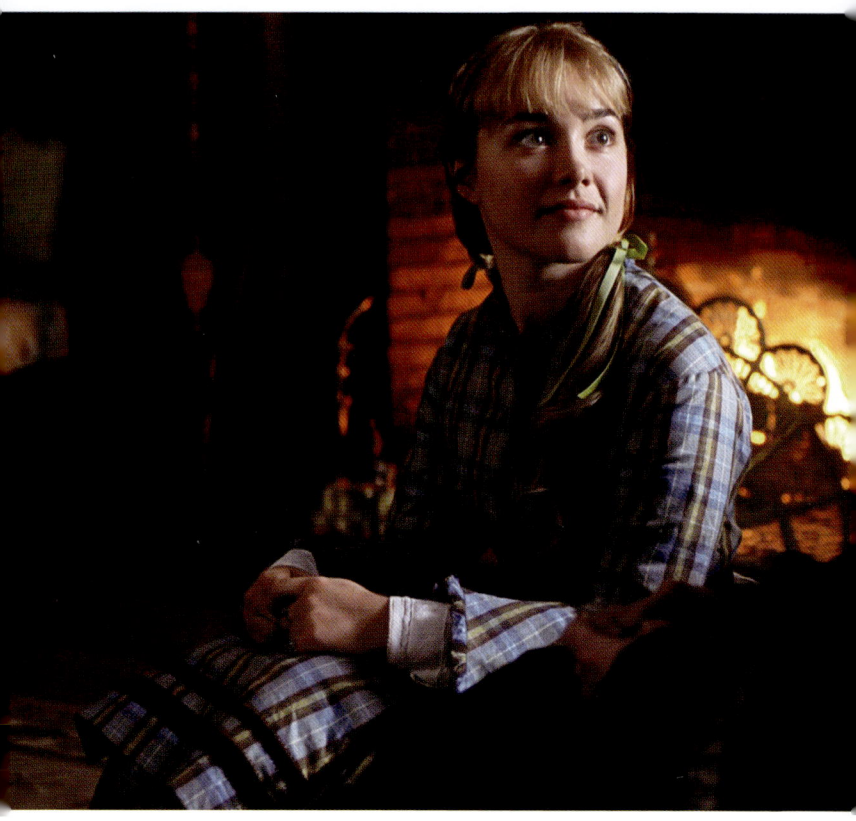

The Reimagining of Amy March

When Florence Pugh accepted the role of Amy March, she knew the baggage that came with it. Amy was a character who had been disliked by generations of readers who accused her of being shallow, selfish and of stealing Laurie from Jo. Even though Amy is only twelve when she burns Jo's book, it's an act of revenge that's difficult to forgive and forget.

But in Gerwig's capable hands Amy almost steals the film. Gerwig was inspired by rereading the novel and finding Amy to be clear-eyed and ambitious, underlining some of her lines such as "The world is hard on ambitious girls". She was struck by the fact that the March sister who was the most vocal about what she wanted was also the one who was the most hated.

"I'm not a poet, I'm just a woman."

Adult Amy delivers one of the core messages of the film in a loaded conversation with Laurie in her Parisian art studio. He is dismayed by both her disillusionment about her painting ability and her unashamed desire to marry rich.

OPPOSITE: Amy (Pugh) receives some life lessons from Aunt March (Streep).

ABOVE: Amy (Pugh) expresses her frustrations to Laurie (Chalamet).

She snaps, reminding him that women have to be pragmatic because they can't earn their own money, and even if she did have independent wealth it would become her husband's property as soon as they married: "So don't sit there and tell me that marriage isn't an economic proposition, because it is. It may not be for you but it most certainly is for me."

This short speech wasn't in the original script but was inspired by a conversation Gerwig had with Meryl Streep, who plays Aunt March. Streep felt that it was crucial to emphasise that women in that time had no financial

independence whatsoever, depriving them of any real agency.

But it's not just plot exposition, it also informs us that Amy isn't a frivolous, empty-headed mean girl. She recognises her circumstances and is just as passionate about providing for her family as Jo. Gerwig wrote these words just ten minutes before shooting, and it's undoubtedly one of the best scenes in the film.

BELOW: Amy (Pugh) and wealthy suitor Fred Vaughn (Dash Barber).

Creating the World of Little Women: Cinematography

BELOW: The March sisters in their home decorated for Christmas.

When she was thinking about the look of the film, Gerwig decided on a very different approach than the one she used in *Lady Bird*. This time instead of still, composed shots, Gerwig wanted the camera to be as wild and free as the March sisters in the childhood sections of the story, following them through the house as if trying to match their energy and vitality.

These fluid camera moves using a dolly and track would also give this film a sense of immediacy rather than a kind of staid, sterile elegance which Gerwig wanted to avoid. This was not going to be your typical period drama.

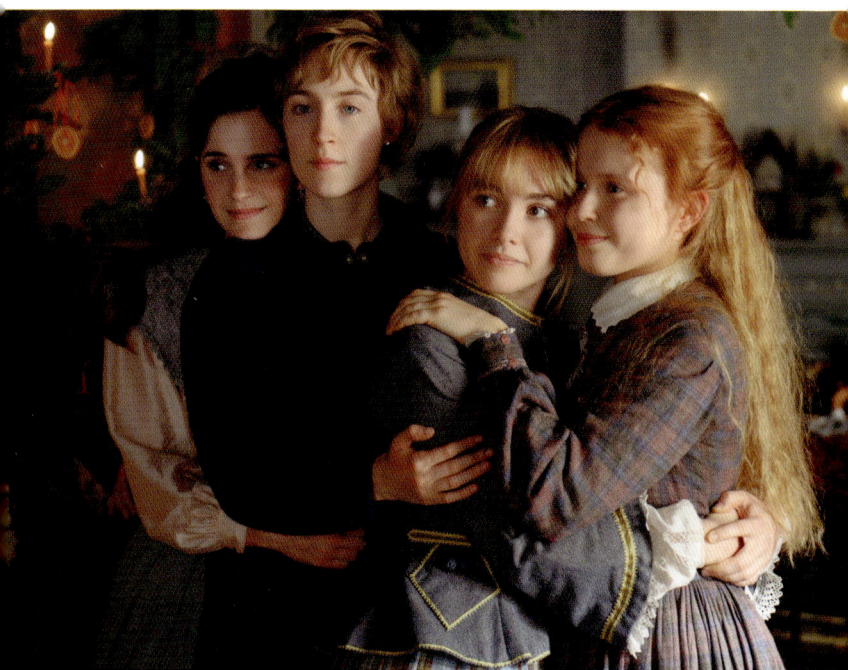

She sought out advice from Steven Spielberg, no less, who showed her all of his research for *Lincoln* (2012), also set during the American Civil War. It's difficult to light interior scenes solely with real candlelight, so Spielberg helped her with methods of imitating the appearance of candlelight with electric lights that he'd used on *Lincoln*. He also strongly recommended that she shoot on 35mm film instead of digitally, and of course she took his advice. Cinematographer Yorick Le Saux, who has worked with celebrated directors like Luca Guadagnino, agreed that the slightly grainy texture of film would be ideal for capturing a more intimate and authentic feel.

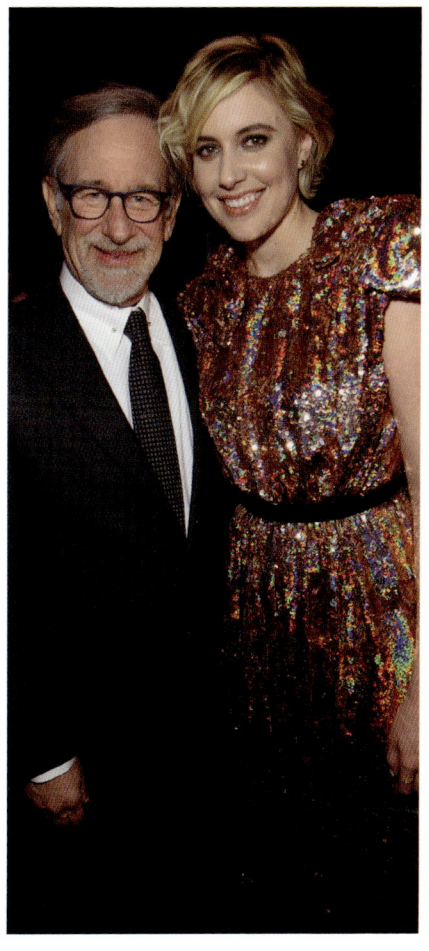

ABOVE: Gerwig and Steven Spielberg attend The National Board Of Review Annual Awards Gala in 2018.

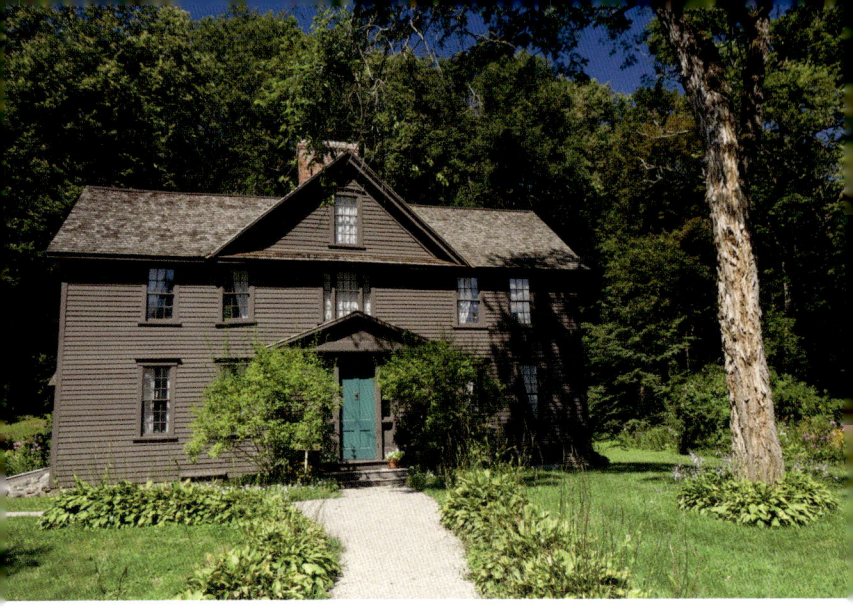

Creating the World of Little Women: Production Design

ABOVE: Orchard House where Louisa May Alcott lived and worked.

For the sake of authenticity Gerwig shot the film in Concord, Massachusetts where *Little Women* is set, only a few miles away from Orchard House where Louisa May Alcott wrote the novel.

In partnership with Gerwig, production designer Jess Gonchor took inspiration from both the interior and exterior of Orchard House when it came to designing the March house. They constructed a full-scale copy of the exterior of Orchard House, as well as a number of other buildings to replicate this New England Civil War-era town.

Gonchor wanted the March house to resemble an old, rather worn jewellery box that might have belonged to a grandmother. The outside might look a bit battered but there are precious treasures within, with personal touches everywhere, such as Amy's drawings. The most important space in the March household is the attic, a space of imaginative play for the sisters but also a haven where Jo can write. The room is a simple but enchanting space, with painted floorboards, a rail of dressing up clothes, and lanterns and dried flowers hanging from the beams.

BELOW: The sisters perform one of Jo's plays in their parlour.

Designing the March Sisters: Costume and Hair

Gerwig needed an expert to take on *Little Women*'s 19th century New England setting while also bringing a sense of freshness and vitality to the costumes. She wanted it to feel like these weren't costumes per se, just clothes that real people of that time would wear. British designer Jacqueline Durran was the obvious choice, having worked on acclaimed period films like *Pride and Prejudice* (2005) and *Mr Turner* (2014) and won an Oscar for *Anna Karenina* (2012).

Perhaps the most crucial task was establishing a different look for each of the March sisters, in both childhood and adulthood, that could also form a cohesive whole. Gerwig

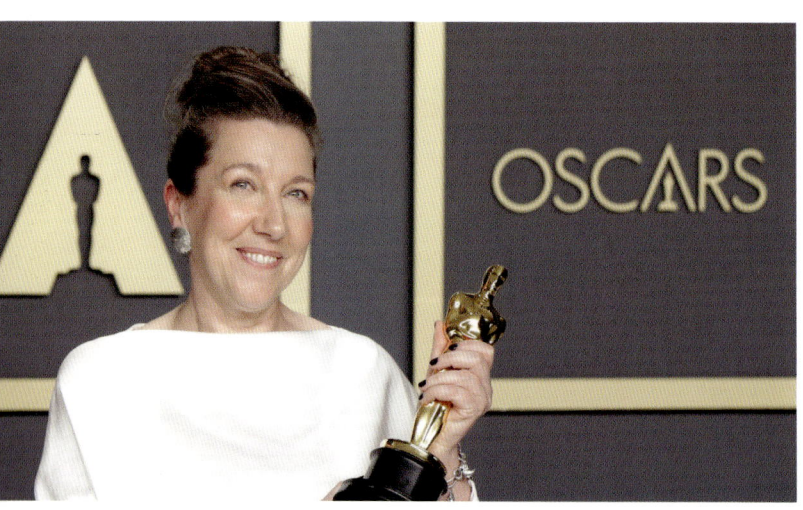

ABOVE: Jacqueline Durran with her Academy Award for Best Costume Design for *Little Women*.

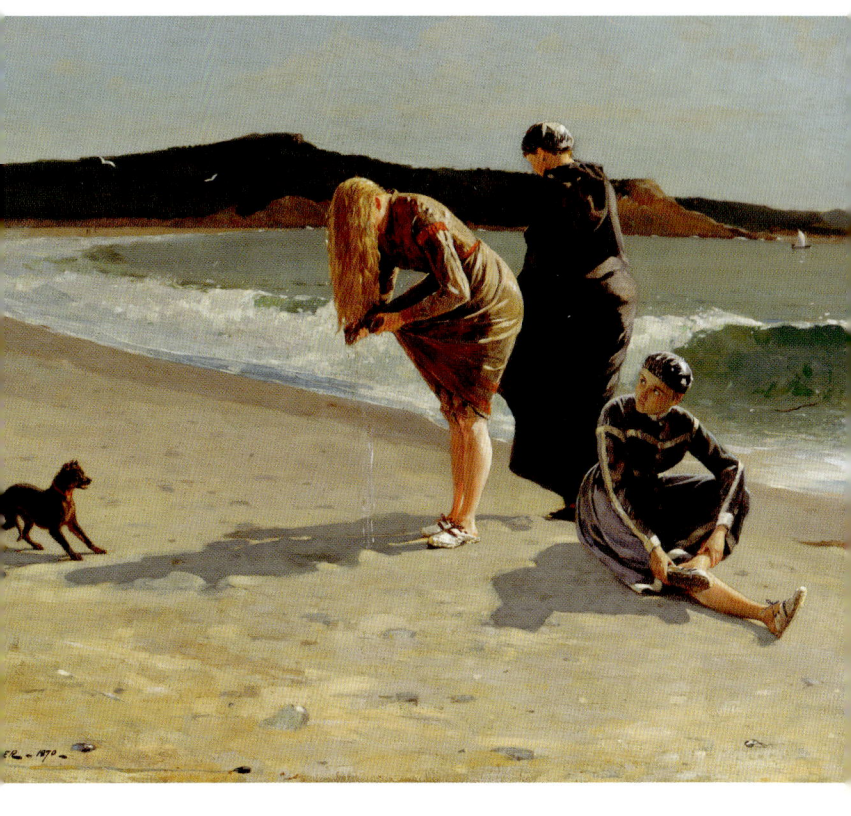

and Durran spent time at a London costume shop poring over paintings and photographs from the time period, searching for an essence of the individual sisters. Durran was also inspired to seek out images of female radicals from the American Civil War era, the kind of women who would've been contemporaries of Louisa May Alcott.

ABOVE: *Eagle Head, Manchester, Massachusetts (High Tide)* by Winslow Homer, 1870, a painting that directly inspired Gerwig's vision of the Marches' day on the beach.

Jo

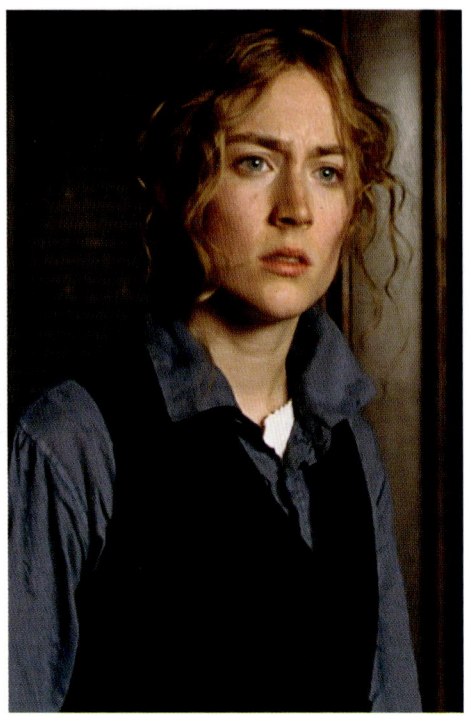

Gerwig and Durran knew they needed to express Jo's rebellious spirit. Eschewing restrictive corsets and hooped skirts, Jo is dressed in simple cotton dresses paired with cardigans and men's waistcoats, all in shades of indigo and red. Sometimes she finishes them off with a masculine neckerchief. In the childhood scenes her waist-length hair is always free and loose, and she sometimes wears a newsboy-style cap for an extra androgynous flourish. She also has a bottle-green velvet military jacket that she only wears while writing, as if she needs to wear it to achieve her ambitions.

She and Laurie swap items of clothing throughout their childhood. Most notable is a yellow waistcoat with a red pattern that he wears when she mock proposes to him with a ring, but she then wears it during his very real marriage proposal to her. It's an ingenious touch, a visual reminder

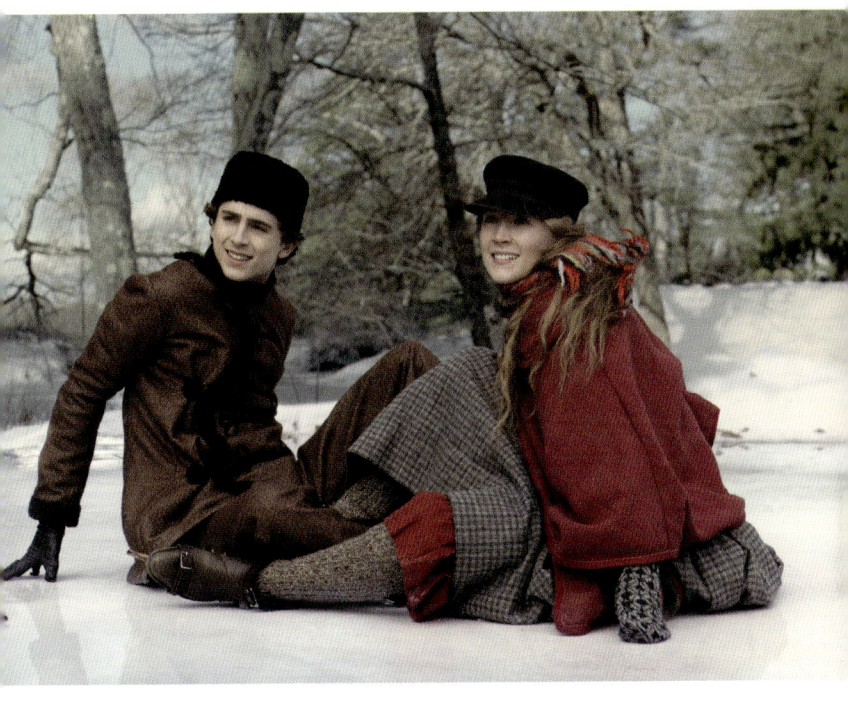

OPPOSITE: Adult Jo (Ronan) in her men's shirt and waistcoat.

ABOVE: Younger Jo (Ronan) wears a newsboy cap to go skating with Laurie.

that the two of them are like two halves of the same person. Her short haircut, which she reveals having sold her hair to pay for Marmee's ticket to Washington, is based on the wavy crop sported by pioneering female aviator Amelia Earhart.

In adulthood her costume and hairstyle mature a little but retain a masculine edge. She keeps her hair up in a loose bun and wears the closest thing possible to a gentleman's suit.

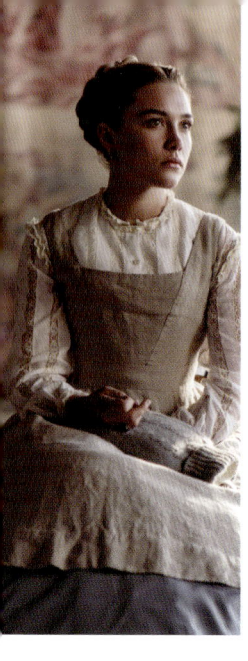

Amy

Amy, in some ways the polar opposite of Jo but actually just as ambitious, has a very different style. Her palette is largely made up of soft baby blues and pinks in childhood and her hair is always perfectly styled in exquisitely neat plaits, with a straight fringe to lend a sense of youth. Like her oldest sister Meg, Amy is very concerned with her appearance and always looks polished. As a girl this means ribbons and frills in fairly typical Victorian children's clothes, whereas as an adult woman she always wears a corset and a full hoop skirt, the very height of fashion and the kind of attire Jo wouldn't be seen dead wearing.

Meg and Beth

Meg is certainly the most traditionally feminine of the March sisters, dreaming of marriage and domestic bliss. Her colours were green and lavender, and Durran developed an aesthetic inspired by the Pre-Raphaelite movement of the mid 19th century. The rose pink silk gown and gloves that she borrows for the debutante ball are a deliberate departure from her usual look, representing that she's indulging in a fantasy for just one evening. And for her wedding, Meg wears a flower crown and has her hair loose, evoking a sense of medieval courtly love that so enchanted the Pre-Raphaelites.

The reclusive Beth mostly wears dusky pink and brown, and represents the warmth of the March family home. She and

Jo wear each other's clothes too, as the middle sisters seem to have the closest bond. Her costumes are ever so slightly wonky and don't quite fit, because Beth is so preoccupied with the present moment she's unconcerned about material things. Of course, the beautiful slippers that she embroiders for Mr Laurence (Chris Cooper) match her colour scheme too.

OPPOSITE: Amy (Pugh) in her artist's apron.

BELOW TOP: Meg (Watson)'s wedding day, inspired by the Pre-Raphaelites.

BELOW BOTTOM: Beth (Scanlen) with childlike plaits on the beach with Jo (Ronan).

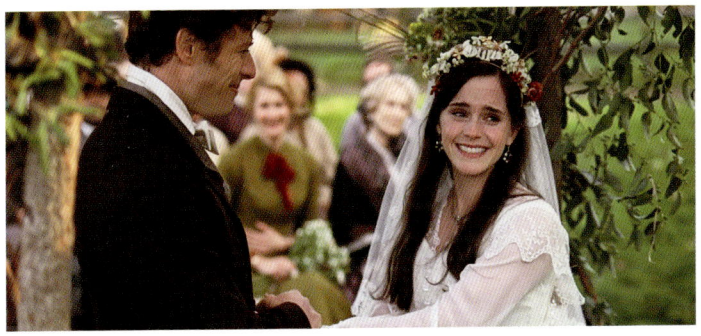

One Defining Scene: Reclaiming Jo March

Friedrich has just left the March house, having come to visit Jo out of the blue. He's blatantly head over heels in love with her, and Amy and Beth are determined that she go after him, sensing that their defiant sister does in fact feel the same.

Gerwig cuts between the three sisters' race to the railway station in the rain with Jo and Dashwood examining her novel's manuscript in the publishing offices. "Frankly, I don't see why she didn't marry the neighbour," he says with

ABOVE: Jo (Ronan) and Friedrich (Garrel) have their Hollywood ending.

OPPOSITE: Jo (Ronan) is exasperated with Mr Dashwood (Letts).

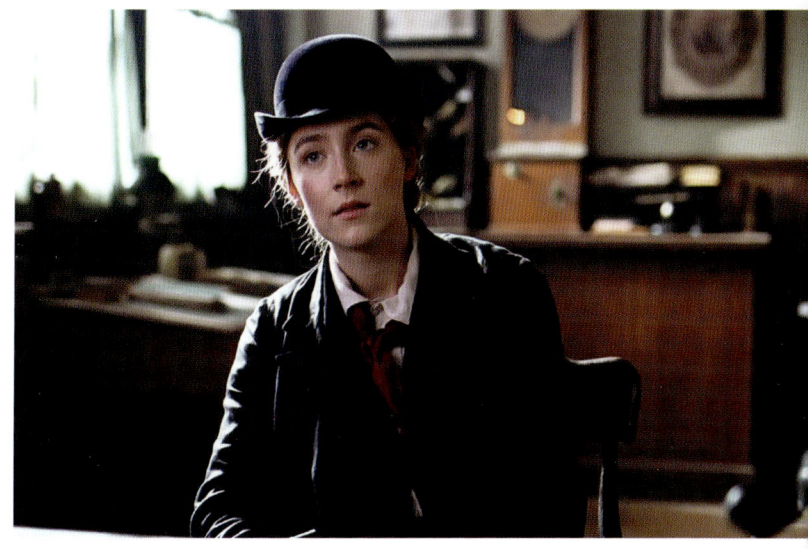

exasperation. He's asking the same question that thousands of *Little Women*'s die-hard Jo and Laurie fans have asked over the past century or so, and it's a wonderfully self-referential moment.

But Jo is determined for her heroine to remain unmarried at the end, while Dashwood insists that "If you decide to end your delightful book with your heroine a spinster no-one will buy it. It won't be worth printing!". With a wry smile she replies, echoing Amy's words: "I suppose marriage has always been an economic proposition, even in fiction,". She agrees to end it his way, and suddenly we return to Jo stepping out of the carriage in the rain, searching for Friedrich in the busy station. They find each other, the music swells and they embrace in an Old Hollywood-style kiss. This ending gains Dashwood's approval, and the conversation proceeds to negotiations over copyright.

The boundary between fact and fiction begins to collapse here. Does Jo marry Friedrich? Is the idyllic scene of Jo and Friedrich running a school in Aunt March's former home real? It's deliberately ambiguous, and Gerwig threads the needle of letting her audience have whichever ending they want.

This deviation from the novel is, ironically, much truer to Alcott's vision. She wanted Jo to remain what she described as a 'literary spinster' just as she herself did, but her readers were desperate for Jo to get married. By giving Jo the same

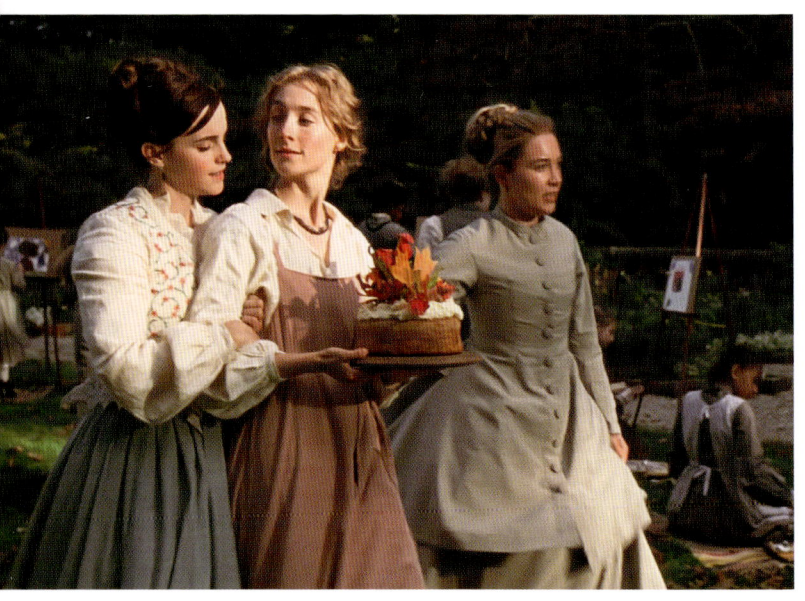

ABOVE: Meg (Watson), Jo (Ronan) and Amy (Pugh) celebrate Marmee's birthday at Jo's school.

OPPOSITE: An edition of Little Women from 1869, recreated in the film.

dilemma as Alcott, Gerwig not only crafts a loving tribute to the author, she also emphasises that the magic of the novel was never tied to who Jo marries. The final moments of Gerwig's *Little Women* see Jo clutching a bound copy of her novel, and we understand that all her joy, grief and passion is alive in this red leather-bound book.

"I want to be great or nothing"

BELOW: Saoirse Ronan, Florence Pugh and Gerwig promote *Little Women* in London.

Little Women cemented Gerwig as a formidable talent able to deliver a box-office hit. Released in the United States on Christmas Day 2019, it grossed over $200m worldwide from a $40m budget – particularly impressive considering it was up against *Star Wars: The Rise of Skywalker* (2019).

It was almost universally critically adored and secured six Oscar nominations, including Best Picture, Best Adapted Screenplay, Best Actress (Saoirse Ronan) and Best Supporting Actress (Florence Pugh). Frustratingly, however, Gerwig was not nominated for Best Director, making it yet another all-male lineup that year.

But, of course, awards aren't even remotely as important as the impact a film has on those who see it. Audiences were deeply moved by Meg, Jo, Beth and Amy's search for identity and meaning in a misogynistic society. Younger generations encountered this story for the first time and saw themselves reflected in these courageous, flawed, creatively brilliant women whose lives, each of them ordinary and extraordinary in their own way, are worth writing about.

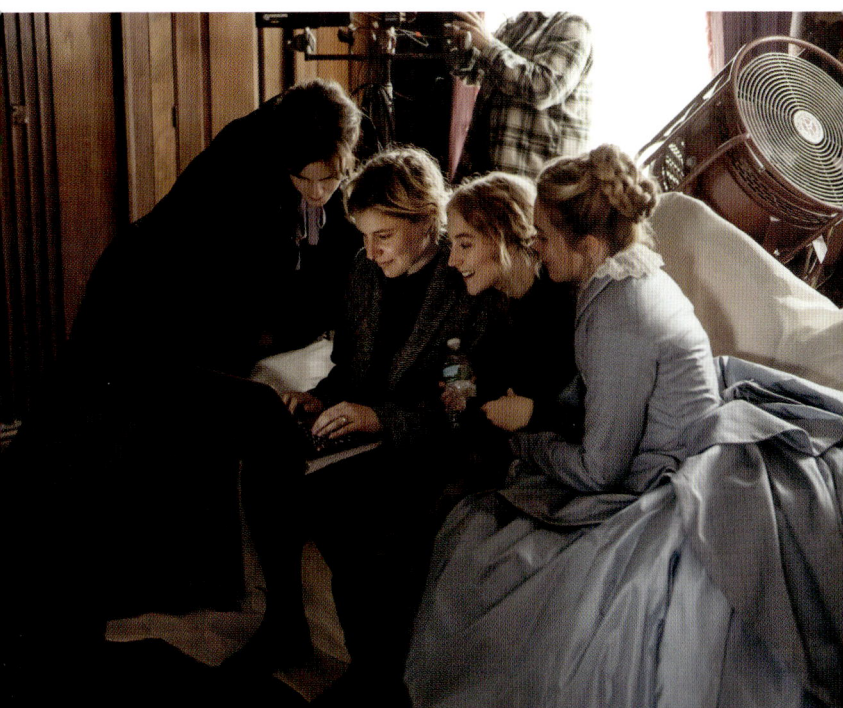

ABOVE: Watson, Gerwig, Ronan and Pugh on the set.

A Return to Acting

BELOW: Gerwig as Babette and Driver as Jack in *White Noise*.

OPPOSITE TOP: Gerwig and Baumbach present *White Noise* at the BFI London Film Festival 2022.

After *Little Women*, Gerwig was due to appear in an Off-Broadway production of Chekhov's *Three Sisters* with Oscar Isaac, but sadly it was cancelled due to the Covid pandemic. She did end up returning to acting but not on the stage: she played the supporting role of Babette in her husband Noah Baumbach's *White Noise* (2022). It was her first role since 2016 and it also reunited her with Adam Driver, who she acted with a decade earlier in *Frances Ha*.

In a performance that reminds us just how skilled an actor she is, Gerwig brings a believability and humanity to some very stylised dialogue in a heightened version of mid-1980s America. Adam Driver's Professor Jack Gladney has to

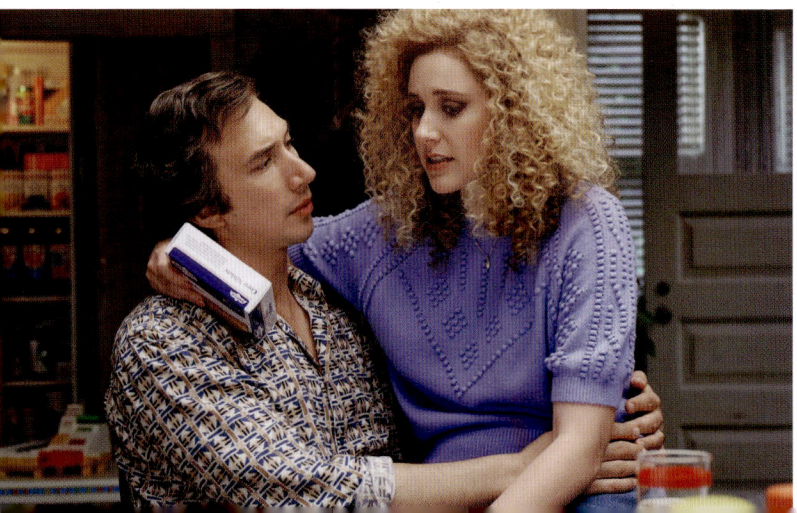

reckon with his impending mortality after he is exposed to a cloud of toxic chemicals. He relies on his wife Babette to be a source of comforting stability, but it emerges that she has been grappling with her own debilitating fear of death and has been secretly taking a black market medication to alleviate it.

It might seem unlikely, but Gerwig and Baumbach's next project together would expand on a similar theme of self-actualisation in the face of chaos and uncertainty, albeit with a few more pink sequins involved. Just as Babette tries to suppress her existential terror, so a certain iconic blonde doll comes face to face with what it means to be mortal.

ABOVE: Babette (Gerwig) teaches an exercise class.

Barbie

BELOW:
Barbie herself is an elusive cultural icon.

OPPOSITE TOP:
Gerwig and Robbie on set.

A Barbie film sounded like a terrible idea. How on earth could anyone adapt a toy with no personality or narrative? A global phenomenon but a doll that's been pilloried for promoting unrealistic beauty standards to those same little girls that love her?

A live action feature film based on toy company Mattel's best-known product had been in development as far back as the 1980s. It was a stop-and-start process over many years with various studios in charge at different points, but when an incarnation with Sony starring comedian Amy Schumer as the eponymous doll fell apart in 2017, it was time for some new blood.

Margot Robbie had had her eye on the project for a while and seized the opportunity to produce the film. As a huge admirer of both *Lady Bird* and *Little Women*, Robbie knew that the only candidate to

write and direct it with a perfectly calibrated balance of irony and earnestness was Gerwig. When they met, Robbie was drawn to Gerwig's intelligence, the strength of her creative voice and her confidence that she could helm a film with an over $100m budget – ten times the cost of *Lady Bird*.

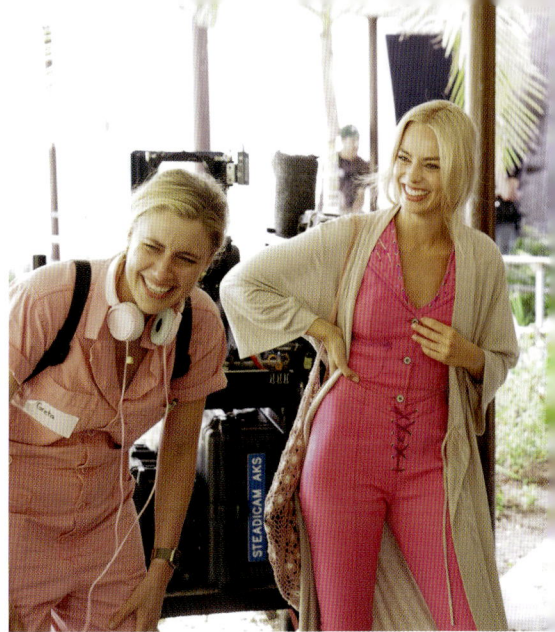

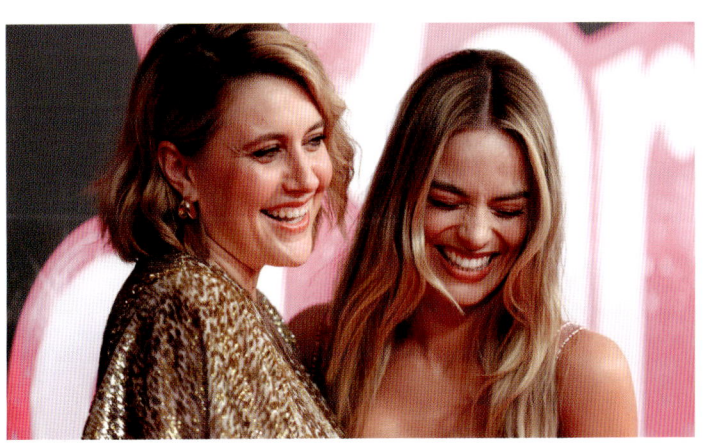

ABOVE: Gerwig and Robbie attend a *Barbie* event in Sydney, Australia, 2023.

LEFT: Barbie (Robbie)'s perfect plastic feet.

Greta Gerwig's vision was a pastel coloured, sharply funny fantasia that embraces all the contradictions of the Barbie doll as a piece of pop culture. Margot Robbie's Stereotypical Barbie is pure plastic perfection living in a matriarchal utopia where the Kens are superfluous, but thoughts of her own mortality shake the foundation of her identity. Drawing on philosophy and even religion, Gerwig manages to imbue a giant blockbuster with playfulness, wit and invention while making a profound statement about the nature of womanhood.

Greta and Barbie

At first glance, *Barbie* might seem like a huge departure for Gerwig, the former queen of Mumblecore cool. But think back to her childhood and teenage years and you'll be reminded that she has always loved the spectacle of Hollywood musicals, and she still loved playing with dolls at the age of thirteen after her friends had put them down for good.

Gerwig's mother Christine did not encourage her to play with Barbies when she was growing up. Like many liberal parents of her era, she didn't approve of Barbie's impossible proportions and the sense that she might be a step backwards for feminism. Gerwig mostly played with hand-me-down Barbies from neighbours, until her mother eventually relented and gave her her own brand-new doll.

LEFT: A collection of vintage Barbies.

BELOW: Gerwig and a life-size version of a Barbie car at a photo call in Los Angeles, 2023.

Writing Barbie

Cut to a few decades later and although Gerwig was scared to take on such a huge project, she was also intrigued by the inherent weirdness of trying to make a film about one of the defining objects of the 20th century. Barbie is, of course, an inanimate doll, but she still carries conflicting connotations of both female empowerment and sexism. It was an opportunity for Gerwig to take creative risks and directly engage with the thornier aspects of Barbie's place

within culture. She also felt it was important to try to remember what she had loved so much about playing with Barbies as a child, as well as the more complicated feelings she had about Barbie as an adult.

She and Noah Baumbach, who she brought on as her writing partner for this film, began working on the script in March 2020. *Barbie*'s irreverent, surprisingly emotional existential tone was partly a result of lockdown, with the pair longing for the impossible experience of thrilling big screen entertainment to be enjoyed collectively in a cinema. The uncertain future of movies at that time meant Gerwig and Baumbach felt free to go for broke, writing something strange, anarchic and heartfelt that they thought would never get approval from Warner Bros. and especially Mattel.

OPPOSITE: Robbie, Ana Cruz Kayne, Gerwig and Hari Nef on the set.

ABOVE: Gerwig, Baumbach and Robbie at the New York premiere of Wes Anderson's *Asteroid City* in 2023.

Who is Barbie?

Margot Robbie plays Stereotypical Barbie in the film: thin, white, able-bodied, blonde and beautiful. As she herself says, "I'm like the Barbie you think of when someone says, 'Think of a Barbie.' That's me." She has no occupation and no inner life whatsoever. But Greta Gerwig's Barbieland is populated by a diverse cast of other Barbies of different races and body types, reflecting the more inclusive range of dolls that Mattel produces today.

They also mirror the huge range of careers that Barbie has had over the years. For example, Issa Rae's President Barbie resides in a pink White House, Alexandra Shipp plays Writer Barbie, Sharon Rooney is Lawyer Barbie and Hari Nef is Doctor Barbie. Nef's casting is especially significant in that it clarifies that Gerwig's vision is inclusive of transgender women.

Gerwig was keen to emphasise that Barbie can be an aspirational figure in a more positive sense, pointing out that an astronaut Barbie was launched in 1965 before Neil Armstrong walked on the moon, and even before women in America could open bank accounts independently. Gerwig manages to be earnest while keeping things very tongue-in-cheek, with jokes about discontinued Barbies like pregnant doll Midge (Emerald Fennell).

OPPOSITE TOP: Stereotypical Barbie (Robbie) lives a perfect life in Barbieland.

OPPOSITE MIDDLE: Issa Rae as President Barbie.

OPPOSITE BOTTOM: The Barbies are appalled by Stereotypical Barbie's flat feet.

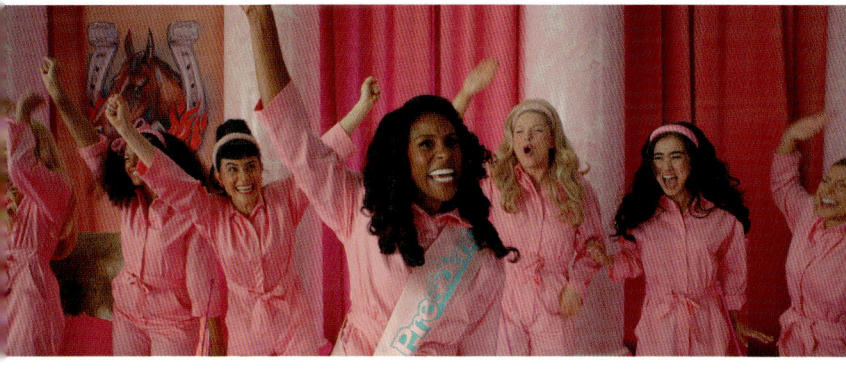

This Barbie is Having an Existential Crisis

Stereotypical Barbie starts thinking about death, externalised by her perfectly arched plastic feet suddenly becoming flat. She's forced to leave her comfortable life as a toy behind and seek out Gloria (America Ferrera), the unhappy woman who owns her in the real world. In travelling to the Real World, she must confront both what it means to be human *and* what it means to be a woman.

Hers is a journey of self-discovery from a world where there is no ageing, pain or death to one that is full of anger, chaos and shame. As unlikely as it might sound, it's an arc that's reminiscent of Adam and Eve's banishment from the Garden of Eden and was strongly influenced by Greta Gerwig's experience at Catholic school. Gerwig even adds a sly reference to Michelangelo's *The Creation of Adam* when Barbie and her creator Ruth Handler (Rhea Perlman) briefly touch fingers when Ruth passes her a cup of tea.

Barbie's worldview is shattered by the misogyny she experiences, both in the Real World and once Ken

brainwashes the other Barbies to become self-hating, subservient and truly plastic. Her collapse into feelings of inadequacy was inspired by Gerwig reading the parenting book *Reviving Ophelia* by Mary Pipher. The book highlights how teenage girls abruptly lose the confidence they had as young children and start diminishing themselves to comply with societal expectations. Seeing Barbie's distress, Gloria sighs and says that "It is literally impossible to be a woman. You are so beautiful and so smart, and it kills me that you don't think you're good enough."

In the ensuing monologue, Gloria vents about the barrage of conflicting expectations women endure and all the never-ending work they do to ensure that they're likeable in a patriarchal world. Through this powerful speech, Greta Gerwig dissects the state of contemporary womanhood and all the confusion and anguish it inflicts on those who live in it. At this moment, Barbie seems to have become fully human and her self-actualisation is complete.

OPPOSITE: Barbie (Robbie) is faced with a choice.

RIGHT TOP: Gloria (America Ferrera).

RIGHT: Barbie (Robbie's) journey to self-awareness begins.

I Am Kenough

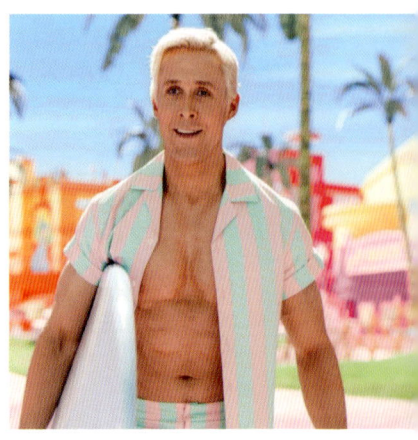

Just as Barbie must look within to find her true human self, so her permanently anxious arm candy has to reckon with living in Barbie's shadow and figure out who he is without her. And compete with the other Kens, of course, especially the Ken played by Simu Liu who can do backflips. Through Ken, Greta Gerwig explores the humour and the tragedy of not merely being a doll, but a doll that is essentially an accessory to Barbie. Ken is not much more meaningful to her than a handbag or hat, but he is much more fragile.

At the beginning of the film Ken is desperate for Barbie's attention; he "only has a great day if Barbie looks at him," we're told. And though Ken becomes an antagonist once he realises that the Real World is ruled by men and then takes over Barbieland, his misguided imitation of patriarchy is extremely funny, pathetic and oddly endearing. It's hard not to sympathise with this intensely self-loathing character who's driven by the basic human need to be recognised and understood.

From the very beginning of the writing process Gerwig and Baumbach knew they wanted Ryan Gosling to play their principal Ken, despite having never met him. Gerwig understood that, like Margot Robbie, Gosling has an ability to be extremely funny from a place of emotional truth. His

skill as a dramatic actor meant Ken's struggle to understand his place in the world would be almost as profound as Barbie's, no matter how silly it appears on the surface. He's grounded by Gerwig and Baumbach's affection for him, and Gerwig was floored by the vulnerability he showed in his final scene with Barbie. Ken personifies how men are also trapped by gendered expectations, and freedom for everyone from these expectations is the path to a more equal society. As Ken himself says, "I'm a liberated man. I know crying isn't weak."

OPPOSITE: Ken (Gosling)'s job is "just beach".

BELOW LEFT: Ken (Gosling) invites himself on Barbie (Robbie)'s adventure.

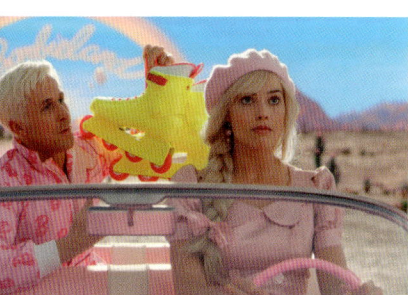

ABOVE RIGHT: Gerwig and Gosling on set.

RIGHT: Ken (Gosling) scores an invite to Barbie's giant blowout party.

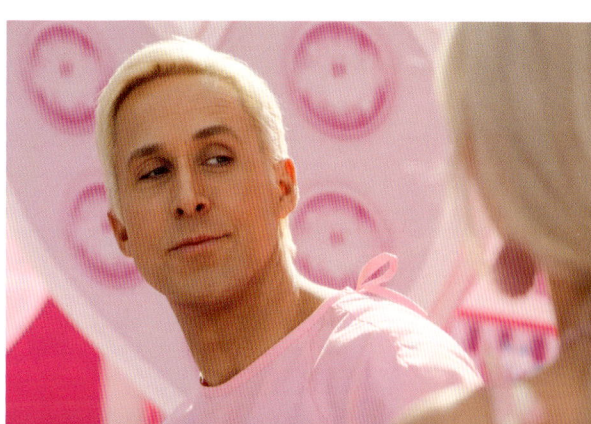

Creating Barbieland

Taking inspiration from some of her all-time favourite films, Gerwig knew from the start that she wanted to create Barbieland the old-fashioned way by building enormous physical sets in a studio. Production designer Sarah Greenwood and set decorator Katie Spencer began their research by looking at a real vintage Barbie Dreamhouse and blending the design with mid-century Modernism and Palm Springs architecture.

They decided that, like real Dreamhouse toys, the houses they built for the film shouldn't have walls, doors or stairs, because children would simply lift their Barbies from an

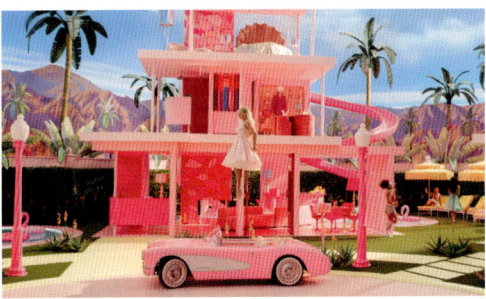

LEFT: Barbie (Robbie) floats down from her Dreamhouse.

BELOW: A morning in Barbieland.

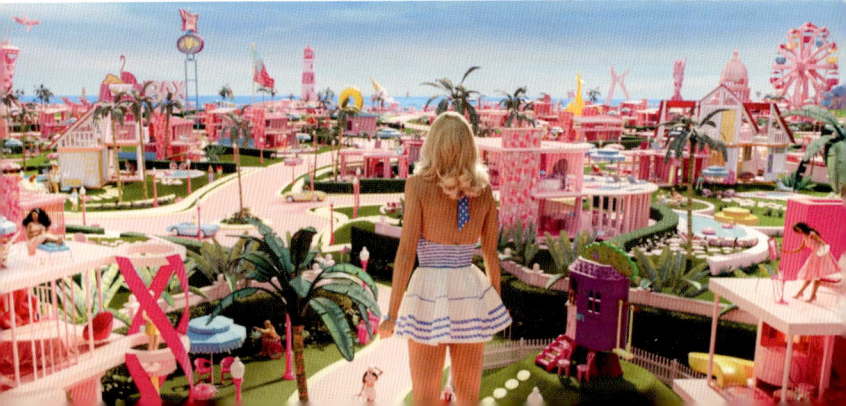

ABOVE: Barbie (Robbie) and Ken (Gosling) travel to the Real World.

RIGHT: Catherine Deneuve in *The Umbrellas of Cherbourg*.

upper floor down to the ground rather than laboriously walking them down a staircase. The sets and Barbie's pink car were also designed to be about 20 percent too small for the actors, imitating the slightly strange proportions of real Barbies in relation to their Dreamhouses and cars.

To complement the full-scale Dreamhouses Gerwig wanted real, hand-painted backdrops, again evoking soundstage musicals like *The Wizard of Oz*, *An American in Paris* and *The Umbrellas of Cherbourg* (1964), along with a dash of *The Truman Show* (1998). A team of artists painted a huge purple-tinged mountain range, and Director of Photography Rodrigo Prieto ignored the rules of nature and had multiple sources of light acting as the sun, coming in from every direction at once, because it's never cloudy in Barbieland.

All of this incredible effort ensured Gerwig achieved her goal of creating an 'authentically artificial' world, an impossible 'toyetic' space of fantasy and play, but one that feels as if you could reach out towards the cinema screen and touch it.

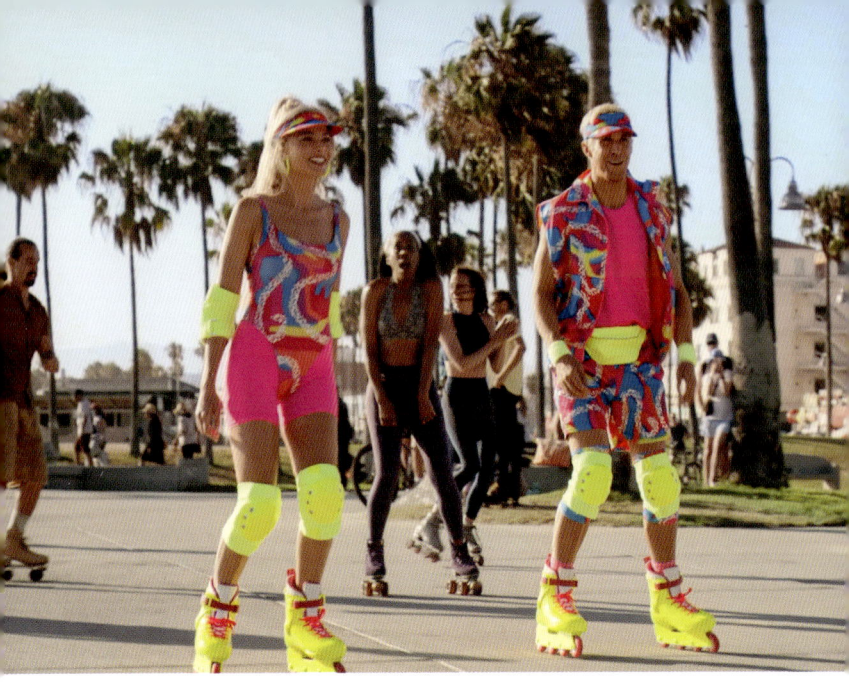

"Did you bring your rollerblades?": Costume

As a doll designed to be dressed up and whose clothes are the uniform for her career, Barbie's outfits are perhaps her defining characteristic. Many of the costumes in the film are direct references to real Barbies, from the black-and-white swimsuit Margot Robbie wears in the prologue as a tribute to the first ever Barbie from 1959, to Barbie and Ken's neon roller skating looks based on Hot Skatin' Barbie from 1994.

Having loved working with her on *Little Women*, Gerwig reunited with costume designer Jacqueline Durran to create the hundreds of costumes needed for all the Barbies and Kens, each of whom had an outfit change for almost every scene. Gerwig and Durran dived into the Mattel archive,

focusing mostly on Barbies from the 1960s through to the late 1980s to find inspiration for some of the most outlandish looks.

OPPOSITE: Barbie (Robbie) and Ken (Gosling) arrive at Venice Beach in their rollerblading look.

BELOW MIDDLE: The film's tribute to the first Barbie.

BELOW BOTTOM: Barbie (Robbie)'s Brigette Bardot-inspired beach look.

Barbie's pink-and-white gingham dress from the beginning of the film is a spin on an outfit worn by 1960s blonde icon Brigitte Bardot. When she visits the Malibu Beach she's suddenly wearing a minidress in the same gingham print with a matching sunhat and has swapped daisy-themed jewellery for shells. Gerwig and Durran wanted to pay tribute to the idea that real Barbie dolls sometimes came with multiple matching outfits to reflect the activities Barbie was doing, such as switching from day wear to beach wear. The pink boiler suits that all the Barbies wear towards the end of the film as they plot the Kens' downfall are perfect for enacting their secret plan, and match the boiler suits Gerwig herself wore every single day on set.

Kate McKinnon's Weird Barbie, who was partly inspired by David Bowie, has a more left-field look. A doll that's been played with just a little bit too aggressively, Weird Barbie's face has been drawn on and she wears a vivid pink dress with puff sleeves paired with acid yellow snakeskin boots. Her hair is short with pastel streaks and sticks straight up in the air as if a child has drawn on it and then randomly hacked at it with scissors.

OPPOSITE: The Barbies, Sasha, Gloria and Allan (Michael Cera) don pink boiler suits.

ABOVE: Kate McKinnon's Weird Barbie is constantly doing the splits.

Kenergy through Costume

For the Kens, meanwhile, Durran obviously did take inspiration from real Ken dolls but also had to make sure they never outshone the Barbies. For example, the Kens all wear the same white-and-gold boiler suits at the party

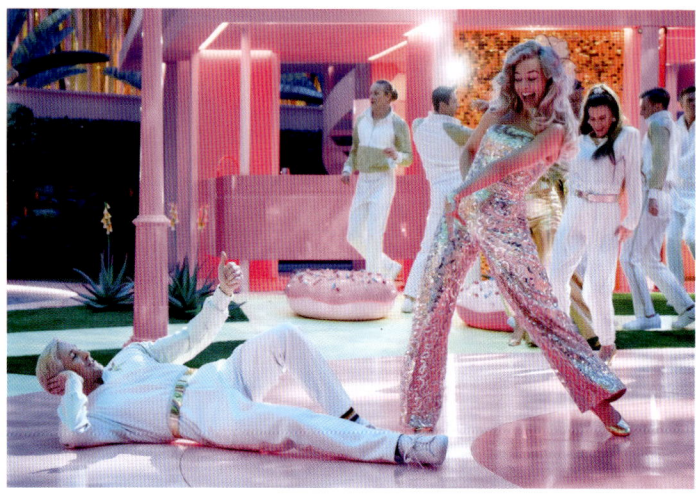

ABOVE: Barbie (Robbie) and Ken (Gosling) on the dance floor.

RIGHT: Ken (Kinglsey Ben-Adir), Ken (Gosling) and Ken (Ncuti Gatwa) brace themselves for battle.

at the beginning of the film to complement the Barbies, each of whom gets a uniquely stunning outfit. It visualises the Kens' low social standing in Barbieland – who even notices them next to the breathtakingly beautiful Barbies?

But once Ryan Gosling's Ken realises that patriarchy governs the Real World, his sartorial senses change dramatically. Taking inspiration from masculine icons like Marlon Brando and John Travolta in *Grease* (1978), Ken sports a more outlandish look. His misguided understanding of patriarchy leads him to wear a lot of equine-themed clothing, from a silver necklace depicting a horse's head within a horseshoe to a headband patterned with horses and lightning strikes.

But the star of his wardrobe is undoubtedly his floor-length mink faux fur coat. When they began discussing Ken's transformation, Gerwig and Gosling found they shared a love for macho icon Sylvester Stallone and the fur coat he wore in the early 1980s. Giving Ken his own outrageous white fur in tribute to Stallone was a stroke of comic genius. Durran and her team even lined the coat with, you guessed it, more images of horses.

ABOVE: A more confident Ken (Gosling) plays it cool with Barbie (Robbie).

One Defining Scene: I'm Just Ken

Barbie isn't a musical as such, and yet for five glorious minutes Gerwig brings to life the kind of set piece that made her want to make films in the first place: an absurd but dazzling song-and-dance number featuring all the Kens performing in a Dream Ballet.

Gerwig had requested that songwriters and producers Mark Ronson and Andrew Wyatt come up with the most maximalist composition that they could. The song 'I'm Just

LEFT: Gosling performs 'I'm Just Ken' at the Oscars in 2024.

BOTTOM LEFT: The Kens go to war on the Malibu beach.

Ken' is a wonderfully silly anthem about the search for self-worth that evokes 1980s power ballads with an orchestra, synth and guitar solos.

It begins with Ryan Gosling's Ken in soulful mode, shirtless and sitting on the edge of his Mojo Dojo Casa House as the sun rises, fists clenched in a parody of masculine emotion. Now adorned in his fur coat, headband and leather gloves, he gathers his troops and storms the Malibu Beach on a horse-headed pedalo, wielding sports equipment as weapons against Simu Liu's Ken. It's a plastic *Saving Private Ryan* (1998).

The Dream Ballet

Chaos ensues while Ken sings about wanting to experience real love, and then Greta Gerwig takes her most audacious creative risk, transplanting the Kens into an abstract dream space via white sparkles. Inspired by a sequence with Gene Kelly and Cyd Charisse in *Singin' in the Rain*, the Kens dance on a vast pink-and-blue soundstage set that seems to go on forever. They're dressed all in black like the T-birds from *Grease* but with bright Barbie pink socks, and their moves are *West Side Story* (1961) meets ballet with some macho bicep-flexing.

The camera looks down on them from on high as they move in lines and create a triangle, with Gosling's Ken and Liu's Ken facing off in the middle. But by the end the Kens find kinship and unity, joining hands as they all sway together. They realise that they're enough just as they are, and the words "I'm just Ken" become triumphant, instead of despairing. What could be more perfect for *Barbie* than the Kens singing and dancing their feelings out?

The Dream Ballet was in the script from the beginning, but Gerwig had to fight to keep it in the film. In various meetings the necessity of the sequence was questioned, but she rightfully stuck to her guns and managed to shoot it in just one day. 'I'm Just Ken' and the Dream Ballet epitomises Gerwig's ambitions as a filmmaker: to create sequences that are thrillingly entertaining, provoke an emotional response and are in touch with cinema of the past. Gerwig's love for her craft radiates from the screen.

OPPOSITE TOP: Ken (Simu Liu) shows off his superior moves.

OPPOSITE MIDDLE: The Kens finally accept themselves.

OPPOSITE BOTTOM: The Dream Ballet in *Singin' in the Rain* with Cyd Charisse and Gene Kelly.

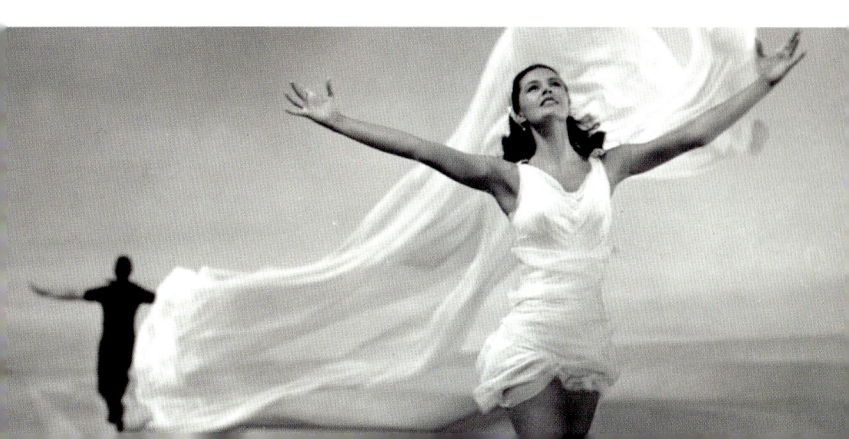

Living in a Barbie World

Summer 2023 was a phenomenal year for cinema, with the simultaneous release of *Barbie* and Christopher Nolan's long anticipated *Oppenheimer* breaking box office records. Audiences came out in droves for *Barbie*, many of them in large groups wearing pink outfits in tribute and bringing the celebratory atmosphere into the cinemas. The film was instantly adored as a joyful, vibrant paean to being a woman, while also speaking to the pressures and impossibly high standards that women face.

The film was nominated for eight Oscars, including Best Picture, Best Actor for Ryan Gosling and Best Supporting Actress for America Ferrera. Sadly, Gerwig wasn't nominated for Best Director this time, but she and Baumbach were nominated for Best Adapted Screenplay. Gosling didn't take

LEFT: The Screen on the Green in Islington, London, screening *Barbie* and *Oppenheimer* in July 2023.

OPPOSITE TOP: Gerwig and Robbie accept the award for Cinematic and Box Office Achievement at the Golden Globes 2024.

home the Oscar that night, but he and many of the other Kens did perform a show-stopping rendition of 'I'm Just Ken' inspired by Marilyn Monroe singing 'Diamonds are a Girl's Best Friend' in *Gentlemen Prefer Blondes* (1953).

But more important than Oscar recognition is that the critical and commercial success of *Barbie* is likely to encourage studios to give more opportunities and higher budgets to other female filmmakers. Women writers and directors are just as capable of managing large scale productions, and they can offer insight and a perspective that audiences all over the world crave. Its legacy is sure to endure far into the future.

LEFT: Barbie (Robbie) understands what it means to be truly human.

Through the Wardrobe: Greta Gerwig's The Chronicles of Narnia

In July 2023 The New Yorker reported that Greta Gerwig had been hired by Netflix to write and direct two film adaptations of C.S. Lewis' Chronicles of Narnia book series. Rumour has it that the first will be *The Magician's Nephew*, a prequel to the better known *The Lion the Witch and the Wardrobe* that has never been adapted for the big

screen before. Emma Mackey, who had a small role as Physicist Barbie, will play The White Witch, the primary villain of the series who was previously played by Tilda Swinton, while Meryl Steep, who appeared in *Little Women*, is in talks to voice Aslan the lion.

A British fantasy saga for children which also acts as a Christian allegory seems like another unlikely next project for Gerwig, but from her filmography we've come to expect the unexpected. Her interest in Catholicism, the potential for Narnia to be a coming of age story plus her unabashed desire to create magical cinematic worlds make her the perfect filmmaker to take new audiences through the wardrobe.

OPPOSITE: C.S. Lewis's Aslan is a Jesus-like figure.

ABOVE: Gerwig and Emma Mackey attend the Met Gala, 2024

Coming of Age in the World of Greta Gerwig

Gerwig's career might be interpreted as a progression from actress to auteur, following a neat trajectory from Mumblecore muse, to indie cinema darling, to box-office titan. But whether consciously or not, Gerwig has always created her own work. From putting on plays for her parents as a child to spending days she wasn't acting in films watching and learning from the directors, she's always been a storyteller as an actress, a writer *and* a director.

She consistently shows a desire to explore and elevate the experience of girls on the brink of womanhood, from her earliest performances right the way through to her Narnia adaptations. The essence of *Lady Bird*, *Little Women* and *Barbie* can be traced back to earlier Gerwig characters like Hannah in *Hannah Takes the Stairs*, Frances in *Frances Ha* and Abbie in *20th Century Women*. Her films are a lens through which we can understand what femininity means and its potential as an inclusive space. Some of her characters are more ambitious than others, but they're all driven by fundamental wants for love, experience and self-knowledge. Gerwig's films are stories of female agency and of finding your place in the world through empathy and

connection with others. They're earnest and they find joy in the richness and complexity of life, no matter how dark their heroines' moments of loneliness and despair.

Her passion for cinema as an art form also means her films are steeped in film history. In punctuating a film like *Barbie* with references to classics like *Singin' in the Rain* and *The Umbrellas of Cherbourg*, she's sharing her love for these films while encouraging a younger generation to expand their knowledge and discover cinema for themselves.

Barbie tells Ruth Handler, her creator, that she wants "to be a part of the people that make meaning, not the thing that's made." In making her own meaning through female characters that yearn to be understood, Gerwig articulates a profound human need for self-expression, and makes her audiences, especially women, feel that their creative voice should be heard.

BELOW LEFT: Gerwig and Ronan on the set of *Little Women*.

BELOW RIGHT: Ruth Handler (Rhea Perlman) and Barbie (Robbie) share a moment.

Image Credits

(t) = top, (m) = middle, (b) = bottom, (c) = centre, (l) = left, (r) = right

Page 4 Album/Alamy; 6 LANDMARK MEDIA/Alamy; 7 Stephanie Cardinale - Corbis/Alamy; 8 Photo 12/Alamy; 9 (t) Jim Spellman/Getty; 9 (b) VALERY HACHE/Getty; 10 trekandshoot/Alamy; 11 (t) Photo 12/Alamy; 11 (b) Phot 12/Alamy; 12 Everett Collection, Inc/Alamy; 13 (l) Moviestore Collection Ltd/Alamy; 13 (r) Allstar Picture Library Limited/Alamy; 14 Glasshouse Images/Alamy; 15 Emma McIntyre/Getty; 16 Everett Collection, Inc/Alamy; 17 Album/Alamy; 18 (l) Cinematic/Alamy; 18 (r) Moviestore Collection Ltd/Alamy; 19 Album/Alamy; 20 (t) Moviestore Collection Ltd/Alamy; 20 (b) Photo 12/Alamy; 21 Cinematic/Alamy; 22 Cinematic/Alamy; 23 (t) GERARD JULIEN/Getty; 23 (b) Cinematic/Alamy; 24 Everett Collection, Inc/Alamy; 25 Album/Alamy; 26 Moviestore Collection Ltd/Alamy; 28 Associated Press/Alamy; 29 (t) Photo 12/Alamy; 29 (b) Photo 12/Alamy; 30 Pictorial Press LTD/Alamy; 31 Everett Collection, Inc/Alamy; 32 Everett Collection, Inc/Alamy; 33 Photo 12/Alamy; 34 Album/Alamy; 35 (t) Album/Alamy; 35 (b) Associated Press/Alamy; 36 Entertainment Pictures/Alamy; 37 (t) Photo 12/Alamy; 37 (b) Larry Busacca/Getty; 38 Photo 12/Alamy; 39 Cinematic/Alamy; 40 Everett Collection, Inc/Alamy; 41 (t) Everett Collection, Inc/Alamy; 41 (b) Everett Collection, Inc/Alamy; 42 Everett Collection, Inc/Alamy; 43 (t) Album/Alamy; 43 (b) Cinematic/Alamy; 44 Cinematic/Alamy; 45 Photo 12/Alamy; 46 Everett Collection, Inc/Alamy; 47 (t) Entertainment Pictures/Alamy; 47 (b) Photo 12/Alamy; 48 (t) Moviestore Collection Ltd/Alamy; 48 (b) Tommaso Boddi/Getty; 49 Erik Pendzich/Alamy; 50-51 Everett Collection, Inc/Alamy; 52 Everett Collection, Inc/Alamy; 53 The Washington Post/Getty; 54 George Pimentel/Getty; 55 Emma McIntyre/Getty; 56 Moviestore Collection Ltd/Alamy; 57 Moviestore Collection Ltd/Alamy; 58-59 Everett Collection, Inc/Alamy; 60 Photo 12/Alamy; 61 (t) Everett Collection, Inc/Alamy; 61 (m) Glasshouse Images/Alamy; 61 (b) Janet Fries/Getty; 62 Deadline/Getty; 63 Photo 12/Alamy; 64-65 Entertainment Pictures/Alamy; 66-67 Moviestore Collection Ltd/Alamy; 68 UPI/Alamy; 69 Everett Collection, Inc/Alamy; 70 Photo 12/Alamy; 71 (t) Frazer Harrison/Getty; 71 (b) Photo 12/Alamy; 72 Entertainment Pictures/Alamy; 73 Photo 12/Alamy; 74 Entertainment Pictures/Alamy; 75 Everett Collection, Inc/Alamy; 76-77 Photo 12/Alamy; 78-79

Photo 12/Alamy; 80 Photo 12/Alamy; 81 Photo 12/Alamy; 82 jeremy sutton-hibbert/ Alamy; 83 Pictorial Press LTD/Alamy; 84-85 Lifestyle pictures/Alamy; 86-87 Moviestore Collection Ltd/Alamy; 88 Everett Collection, Inc/Alamy; 89 UPI/Alamy; 90 LANDMARK MEDIA/Alamy; 91 LANDMARK MEDIA/Alamy; 92 Everett Collection, Inc/Alamy; 93 Everett Collection, Inc/Alamy; 94-95 Atlaspix/Alamy; 96 Everett Collection, Inc/Alamy; 97 LANDMARK MEDIA/Alamy; 98 Penta Springs Limited/ Alamy; 99 Associated Press/Alamy; 100 Associated Press/Alamy; 101 Album/Alamy; 102 Photo 12/Alamy; 103 Photo 12/Alamy; 104 Moviestore Collection Ltd/Alamy; 105 LANDMARK MEDIA/Alamy; 106 LANDMARK MEDIA/Alamy; 107 LANDMARK MEDIA/Alamy; 108-109 LANDMARK MEDIA/Alamy; 110 LANDMARK MEDIA/Alamy; 111 Jamie McCarthy/Getty; 112 robertharding/Alamy; 113 Moviestore Collection Ltd/ Alamy; 114 UPI/Alamy; 115 FineArt/Alamy; 116 LANDMARK MEDIA/Alamy; 117 Photo 12/Alamy; 118 Album/Alamy; 119 (t) LANDMARK MEDIA/Alamy; 119 (b) LANDMARK MEDIA/Alamy; 120 Photo 12/Alamy; 121 LANDMARK MEDIA/Alamy; 122 LANDMARK MEDIA/Alamy; 123 Associated Press/Alamy; 124 Dave Benett/Getty; 125 Album/ Alamy; 126 Everett Collection, Inc/Alamy; 127 (t) Associated Press/Alamy; 127 (b) Album/Alamy; 128 incamerastock/Alamy; 129 (t) LANDMARK MEDIA/Alamy; 129 (b) Hanna Lassen/Stringer/Getty; 130 LANDMARK MEDIA/Alamy; 131 (t) Chris Jackson/ Getty; 131 (b) Eric Charbonneau/Getty; 132 Album/Alamy; 133 Nina Westervelt/Getty; 135 (t) Album/Alamy; 135 (m) Entertainment Pictures/Alamy; 135 (b) LANDMARK MEDIA/Alamy; 136 LANDMARK MEDIA/Alamy; 137 (t) LANDMARK MEDIA/Alamy; 137 (b) LANDMARK MEDIA/Alamy; 138 Pictorial Press LTD/Alamy; 139 (l) Album/Alamy; 139 (r) Album/Alamy; 139 (b) LANDMARK MEDIA/Alamy; 140 (t) LANDMARK MEDIA/ Alamy; 140 (b) LANDMARK MEDIA/Alamy; 141 (l) LANDMARK MEDIA/Alamy; 141 (r) Album/Alamy; 142 LANDMARK MEDIA/Alamy; 143 (t) Moviestore Collection Ltd/ Alamy; 143 (b) LANDMARK MEDIA/Alamy; 144 Album/Alamy; 145 Album/Alamy; 146 (t) LANDMARK MEDIA/Alamy; 146 (b) LANDMARK MEDIA/Alamy; 147 LANDMARK MEDIA/Alamy; 148 LANDMARK MEDIA/Alamy; 149 Associated Press/Alamy; 150 (t) Moviestore Collection Ltd/Alamy; 150 (m) Everett Collection, Inc/Alamy; 150 (b) Allstar Picture Library Ltd/Alamy; 152 Gavin Rodgers/Alamy; 153 (t) PMC/Alamy; 153 (b) LANDMARK MEDIA/Alamy; 154 Gareth Williams/Alamy; 155 Dia Dipasupil/Getty; 157 (l) Entertainment Pictures/Alamy; 157 (r) Everett Collection, Inc/Alamy; cover Leysanl/Shutterstock.